IMAGES
*of America*

# COHOES

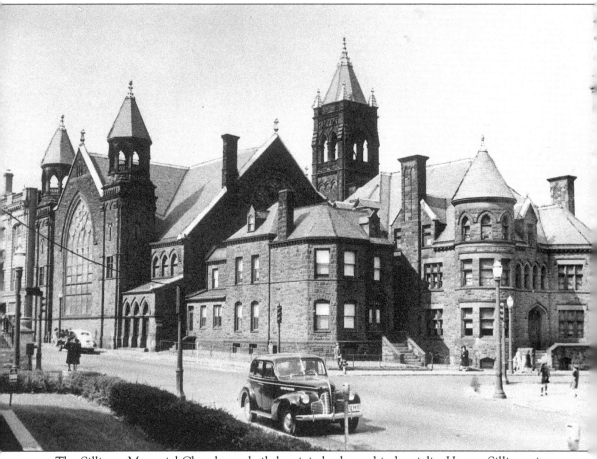

The Silliman Memorial Church was built by civic leader and industrialist Horace Silliman in memory of his parents, Levi and Clarissa. The Romanesque Revival structure stood proudly at the corner of Mohawk and Ontario Streets for nearly 100 years. Unfortunately, the church fell victim to neglect. In 1997, it was demolished by the city, despite objections from many citizens and the strenuous efforts of the historical society to save it.

# ACKNOWLEDGMENTS

We, the Spindle City Historic Society Arcadia Committee, have had the assistance and cooperation of many individuals during the preparation of this book. They loaned us their cherished artifacts and their memories in the form of photographs. We are indebted to them for their generosity. Without their help, this book would have been impossible. We thank Cheryl Alexanian, Donna Baker, Gene Baxter, Miriam Biskin, Paul Bourgeois, Donald Breault, Walter Catallo, Rudolph Cecucci, Evelyn Charette, June Cherniak, Walter Cherniak, Linda Christopher, Ed Clark, Cohoes Public Library, Cohoes Savings Bank, T. Campbell Collin, Marie Costello, Jayne Counterman, John Craner, William Dillon, Karen Donlon, Ed Dudek, Paul Dunleavy, Edward Fisher, William Fisher, Ellen Gamache, Marie Gennett, Diane Grego, Leah Hill, Rich Hogan, Tom Kessler, Eldora Kiely, Steve Lackmann, Irene LaMarche, Terri LaMarche, Elaine Leonard, Janet Madigan, Jacquie McCarthy, Barbara McDonald, Jane O'Keefe, Mary Orlowski, Bernard Ouimet, Ed Perry, Linda Plouffe, J. R. Renehan, Ed Rigney, Dennis Rivage, RiversPark, Cathy Roylance, St. Rita's Archive, Bernie Shaw, John Shea, Jean Steciuk, Linda Tremblay, Al Urquardt, and Morton Valley for their contributions.

The Spindle City Historic Society hopes this book, through its photographic record, will strengthen the appreciation for the history of Cohoes. If there have been oversights, or if readers can supplement the information in captions accompanying the photographs, we kindly ask them to inform us. Please contact the Spindle City Historic Society at P.O. Box 375, Cohoes, N.Y., 12047. Your help is always appreciated and vital to expanding our knowledge of Cohoes history.

—The Spindle City Historic Society Arcadia Committee:
Daniele Cherniak, June Cherniak, Walter Cherniak,
Linda Christopher, Mary DeRose, Paul Dunleavy, Walter Lipka,
Bernard Ouimet, Donna Riley, Dennis Rivage, and Tor Shekerjian.

# CONTENTS

Published by Arcadia Publishing
Charleston, South Carolina

Library of Congress Catalog Card Number: 2001089395

For all general information, contact Arcadia Publishing:
Telephone 843-853-2070
Fax 843-853-0044
E-mail sales@arcadiapublishing.com
For customer service and orders:
Toll-free 1-888-313-2665

Visit us on the Internet at www.arcadiapublishing.com

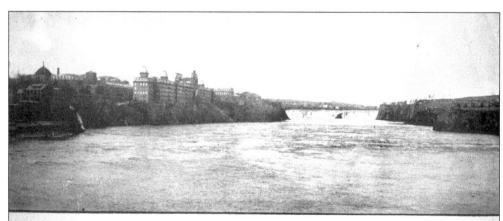

CHUTES DE COHOES ET SECTION MANUFACTURIERE

Be Sure and Visit

# The Great Cohoes Falls . . . 86 Feet High. 1140 Feet Wide.

The Cohoes Falls propelled Cohoes to a leading position in the textile industry during the late 19th century. The falls, which powered the machinery of the Industrial Revolution, now provide hydroelectric power.

4

IMAGES
*of America*

# COHOES

Spindle City Historic Society

ARCADIA
PUBLISHING

# INTRODUCTION

Cohoes began as a farming community of Dutch settlers—the Heamstreet, Onderkirk, Lansing, Fonda, and Clute families, to name a few—and remained one into the early 1800s. Sawmills and gristmills made up the earliest industry. The Clute family built a gristmill a short distance above the falls, and a carding mill was built on the Heamstreet farm opposite Simmons Island. Although farming, and not the mills, was their main source of income, this did not remain true.

Cohoes became an industrial center because of its strategic location near the confluence of the Hudson and Mohawk Rivers and because of its extraordinary natural resource, the Cohoes Falls. Henry Hudson and his crew were the first Europeans to see the falls. The Dutch minister in Albany, Rev. Johannes Megapolensis, first mentions the falls in 1642 in correspondence with friends in Holland. During the 17th and 18th centuries, the falls were viewed as both a natural spectacle and an obstacle to be surmounted on water journeys. Later, the falls were perceived as a source of power to drive the Industrial Revolution.

During the Revolutionary War, while preparing to engage the British at Saratoga, the American forces camped on Van Schaick Island, now part of Cohoes. Earthen fortifications were constructed on Peebles Island, and the Van Schaick Mansion became the headquarters of the Colonial forces. Although these locations were key to the American troops, Burgoyne was defeated at Saratoga and the defenses downriver were never tested.

A pioneering attempt at manufacturing began in 1811 when the Cohoes Manufacturing Company bought 60 acres of land, built several tenements for its workers, and set up a factory to manufacture screws. In 1827, the factory burned and the land was sold to the Cohoes Company. Until 1840, Cohoes consisted of about 20 houses and had a population of 150. Growth was so rapid that the community's population rose to 4,000 by 1848. That year marked the incorporation of Cohoes as a village. Previously, it had been part of the town of Watervliet. Cohoes became a city in 1870.

Two companies were largely responsible for the industrial growth of Cohoes: the Cohoes Company and the Harmony Manufacturing Company. The Cohoes Company built a series of six canals to provide waterpower to prospective manufacturing enterprises. The canals were built so that the same water could be used to power the mills six separate times before it was returned to the river. The Harmony Manufacturing Company was formed in 1836 and built its first mill in 1837. By 1850, the mill was sold and the new owners hired Robert Johnston as manager. Johnston's tenure marked the beginning of the Harmony Mills' success. The company eventually owned a complex of mills that, by 1900, produced 1.6 million yards of cotton cloth

a week. With certainty of employment, people flocked to Cohoes. Irish immigrants building the Erie Canal were joined by French Canadians in the 1870s and 1880s. In the 1880s, the first Italian immigrants came to Cohoes, followed by the Poles, the Russians, the Ukrainians, and many others.

By the 1880s, Cohoes was a one-company town. Following World War I, the union movement, dating to the post–Civil War era, became stronger. Textile mills that dotted the Northeast moved to the South, where they did not have to contend with unionization, strikes, demands for better working conditions, shorter working hours, and higher wages. The Harmony Company liquidated its assets in Cohoes, and the city began years of struggle common to many northeast industrial cities.

Cohoes has a fascinating and exciting past, and its history is a catalyst for the future. Preserving the city's heritage and architecture, made rich by a diverse population, must be uppermost in the minds of Cohoesiers.

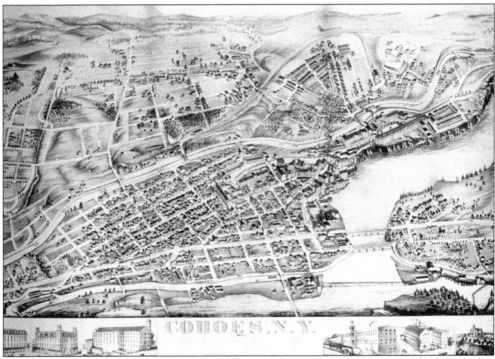

This map, published by Galt and Hoy, shows Cohoes in 1879 with the power and transportation canals and the Mohawk and Hudson Rivers.

8

# One

# HISTORY

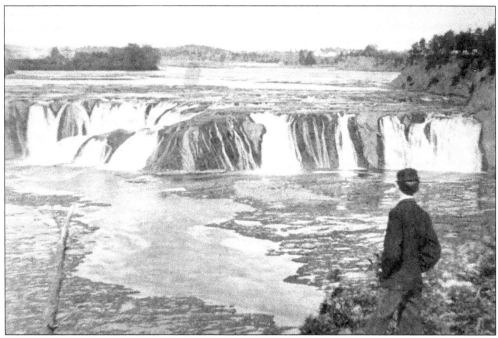

This photograph shows the splendor of the Cohoes Falls. The falls have been home to the legendary escapades of daredevils, the musings of poets and visual artists, and the romantic whims of couples. Today we can still appreciate its beauty, since little has changed in the flow of water and the topography of the land surrounding it. The Cohoes Falls, with a 70-foot drop, are the largest cataract east of Niagara Falls.

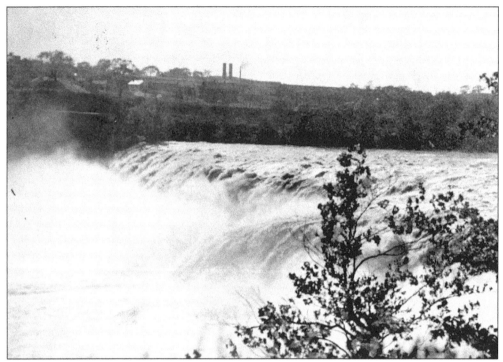

The Cohoes Falls are sometimes a raging torrent, but when water is diverted for hydropower, the falls dry and reveal the shale formations beneath. On April 15, 1899, a daredevil named Bobby Leach went over the falls in a barrel. This feat was witnessed by a crowd of 10,000. Leach survived the plunge, a prelude to his successful barrel trip over Niagara Falls.

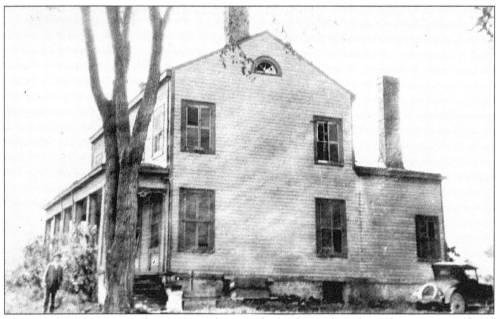

The Murphy farm, seen in this c. 1920s photograph, was located on the Cohoes-Crescent Road along the Mohawk River. After the canal was dug, a bridge had to be built to access the farm.

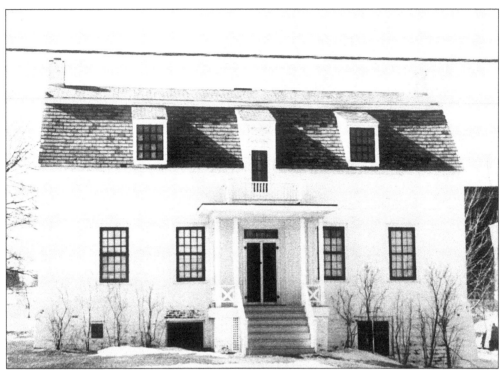

The Van Schaick Mansion, originally the home of Anthony Van Schaick, was built in 1735. During the Revolutionary War, American troops camped behind the mansion to await the arrival of Burgoyne's forces from the north. New York governor George Clinton made the mansion the temporary state capital for four days in August 1777. George Washington visited the house twice in postwar years and left his initials scratched on a windowpane.

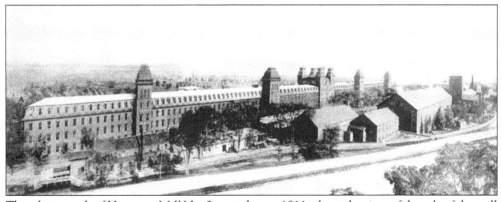

This photograph of Harmony Mill No. 3 was taken c. 1911, about the time of the sale of the mill complex. A portion of the mill's power canal can also be seen.

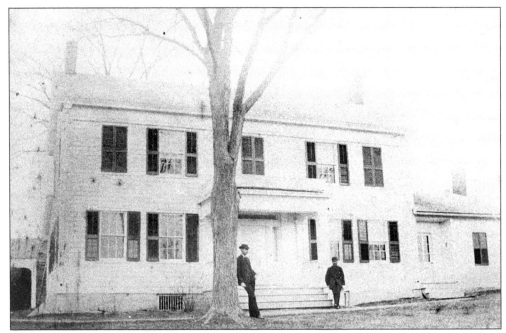

Abram Lansing, a supervisor of music in the city schools and a prominent participant in many of the city's musical ensembles and societies, is leaning against the tree to the left of his house, located on North Mohawk Street. It was commonly known as the Abram Lansing house.

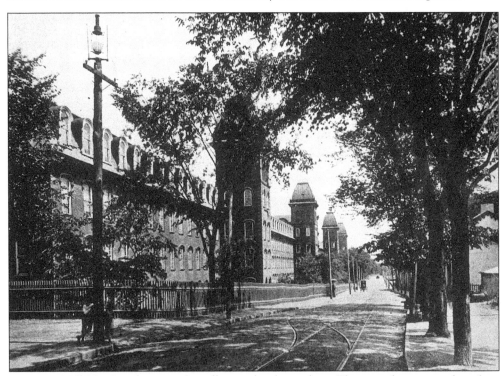

Harmony Mill No. 3 is shown with trolley tracks alongside it. These tracks conveyed workers daily from many points south of the mill.

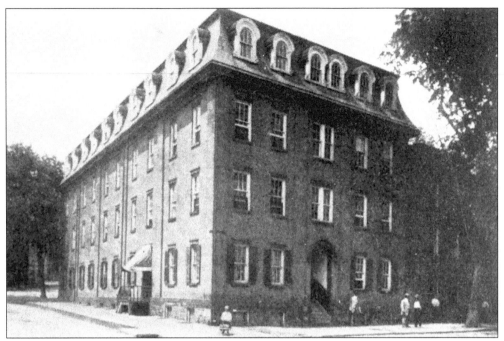

By the 1870s, when mill expansion was essentially complete, the Harmony Mills employed 3,100 people. Neat rows of tenements and boardinghouses were built and owned by the mill and leased to employees. Families were housed in some 800 tenement houses. Unmarried workers often lived in one of five large boardinghouses, such as the one pictured, which may have been located near the foot of Vliet Street.

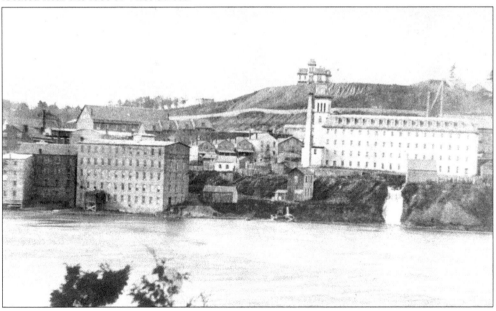

This late-1860s image, rich with detail, reveals the tight cluster of factories and tenements in the bustling mill district surrounding the junction of Mohawk and Remsen Streets. Isolated from the congestion, dirt, and noise of industry but overlooking it all atop Harmony Hill was Longview, the mansion of Harmony Mills superintendent David Johnston.

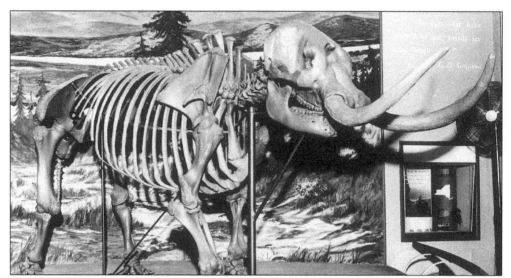

The Cohoes Mastodon was discovered during the excavation for Harmony Mill No. 3 in 1866. The mill is sometimes referred to as the Mastodon Mill for this reason. When the bones were recovered, they were kept at the Harmony Mills office on exhibit, where they were seen by hundreds of people. In 1867, the skeleton was transferred to state ownership and exhibited in the State Cabinet of Natural History in Albany.

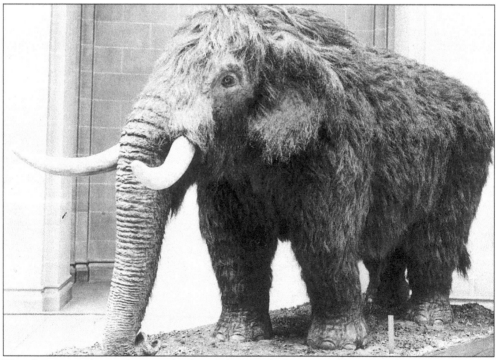

This furry mastodon replica was displayed along with the original bones in the New York State Education Building in Albany until the New York State Museum was relocated in 1976. The skeleton was disassembled and put into storage. After a furious bidding war, the replica found a new home in the Cohoes Public Library. The skeleton was painstakingly cleaned, reassembled, and analyzed in the mid-1990s. It now stands in the lobby of the New York State Museum.

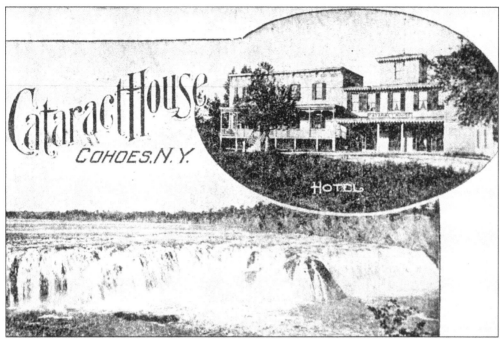

The first Cataract House was built in 1860. It was partly destroyed by fire in 1867 and was rebuilt later that year. Col. William H. Gwynn was hired as manager. The house had a central fireplace large enough to roast a whole ox. Breakfast consisted of steak, fish, eggs, cakes, coffee, and tea. The evening meal was a variation on breakfast plus cold meat. Certain alcoholic beverages were free; others cost extra. The rates were only $2 per day.

Gwynn operated the Cataract House and the adjacent cigar factory. In 1912, he fell ill and returned to England to recuperate. Early in June 1912, the fire alarm sounded—the Cataract House was ablaze. The swing bridge, the only means of access to the hotel, greatly hampered the firemen's efforts to extinguish the flames, causing the total destruction of these buildings. Watchman John Hughes died in the fire.

This c. 1920 view was taken near the present intersection of Manor Avenue and North Erie Street. The abandoned Erie Canal is visible. Canallers referred to the wide portion of the canal as the Head of the Locks. The building near the center of the photograph was a grocery. Most of the buildings in this picture are still standing. The tracks in the foreground were laid to transport construction materials to this site for power canal reconstruction.

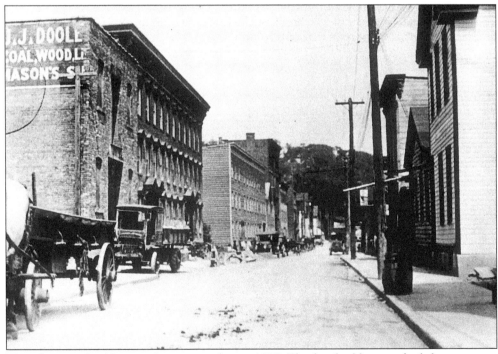

This photograph of Sargent Street was taken c. 1925. The first building on the left is a storage building for lime, plaster, and concrete. The next building is a three-story, four-bay brick tenement. At the time, there were 12 multifloor, multiapartment structures in this area. Today, there are only vacant lots, with one structure standing at the end of the street.

16

This view of Remsen Street shows buildings draped in bunting for the St. Jean de Baptiste celebration in late June. The building on the left with the white stone archway was one of F.F. Proctor's theaters, at one time a popular entertainment center in Cohoes.

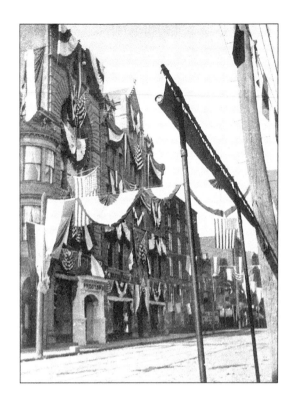

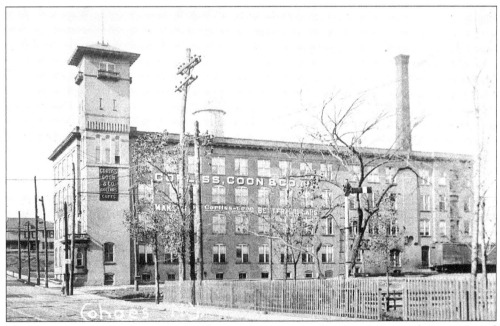

The Corliss, Coon, & Company of Cohoes and Troy was at 31 Ontario Street from 1905 until 1942. The company made collars and cuffs that were sold in five states.

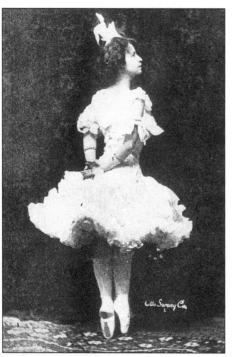

This is an 1890s photograph of La Petite Adelaide. In February 1893, nine-year-old Adelaide Dickey did a benefit performance for the Cohoes Press Club and thoroughly charmed everyone. Later, she was featured at George Lederer's New York Casino and performed there for seven years, the longest engagement at the time. She later married J.J. Hughes, and the couple became one of the most popular dance teams in the vaudeville era.

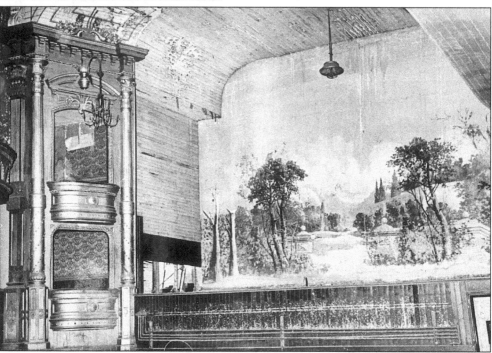

This interior photograph of the Cohoes Music Hall (constructed in 1874) dates from the late 1960s. Little had changed from the day it was closed in 1905. Many luminaries of the day—including Buffalo Bill Cody, John Philip Sousa, Col. Tom Thumb, and Eva Tanguay—played here. The hall was carefully restored and reopened in the mid-1970s. It has continued as a performance hall and today is home to the Eighth Step Coffeehouse.

Eva Tanguay was born in Quebec in 1878. She performed at the Cohoes Opera House and debuted in a variety house in Holyoke, Massachusetts. She had a fiery temper and, during one outburst, carried a pair of scissors onstage and cut the curtain to shreds. This photograph shows her in one of her many attention-getting devices, her penny dress. Eva is credited with at least two films: *Energetic Eva* (1916) and *The Wild Girl* (1917).

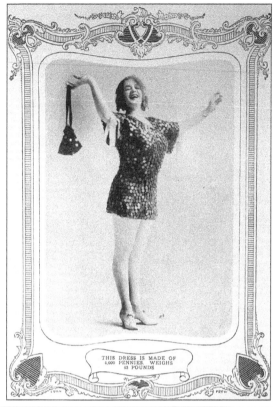

THIS DRESS IS MADE OF 4,000 PENNIES. WEIGHS 45 POUNDS

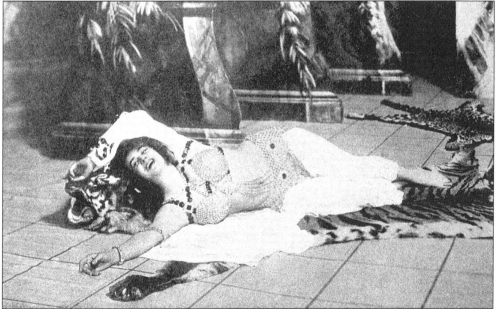

Eva Tanguay's act was unique because of her madcap humor, freakish costumes, and crop of tousled hair. She sang songs that were daring for the time, such as "I Want Someone to Go Wild with Me," "It's All Been Done Before but Not the Way I Do It," "Go as Far as You Would Like," and "I Don't Care." Here, she appears in costume for *Dance of the Seven Veils*.

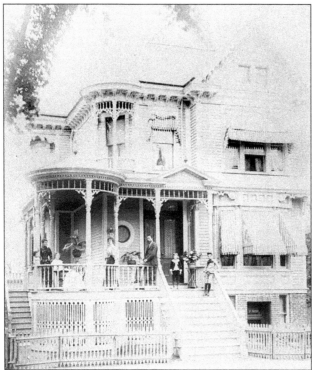

Gathering on the porch on a summer day are members of the Peltier family at their home on Congress Street. Note the entrance at the lower right, where Dr. G. Upton Peltier saw his patients. The home, which still stands, is a beautiful example of a mid-Victorian structure in Cohoes.

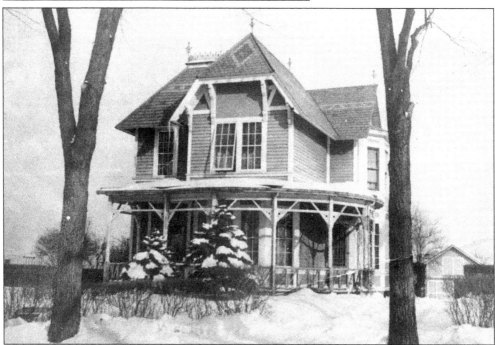

The William J. Dickey House, which was built in 1890, is a fine example of the Stick Victorian style. Dickey built the house when he was superintendent of the Egbert & Bailey Woolen Mills. Now on the State and National Registers of Historic Places, the house still stands at the top of Imperial Avenue.

# *Two*

# TRANSPORTATION

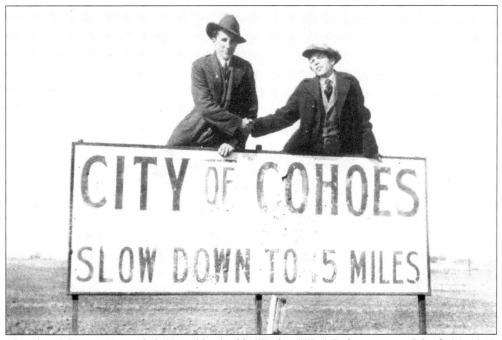

Theodore Thomas Hampel (left) and his buddy Wesley (Wes) Bishop pose on March 24, 1918, at the crossroads near the head of Columbia Street. Theodore T. Hampel was born in Cohoes in 1901 and lived on Simmons Avenue with his parents and five siblings. After he spent time as a minister in Clarksville, he returned to Cohoes, where he was active on the board of trustees at St. James Methodist Church.

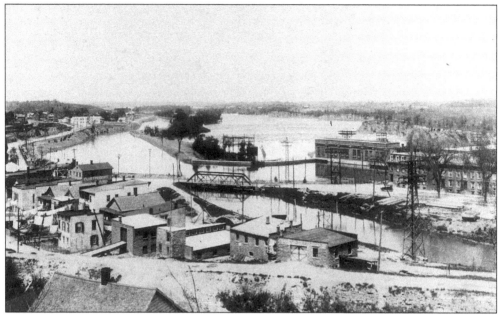

This *c.* 1900 photograph of the Cohoes Company canal, taken from Reservoir Street opposite Sunset Park, provides a good vista and a view of other points of interest. The canal was constructed to furnish waterpower for the Harmony Mills and other manufacturers. The bridge and a portion of the canal are gone. The remaining canal is still used to generate power.

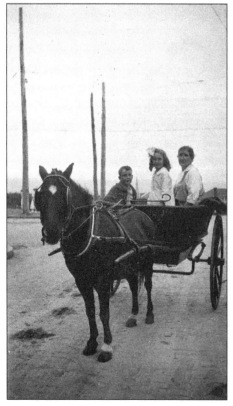

This well-behaved horse pulls a wagon holding Leo Morin, Arlene Reil, and Julia Rose Morin along a downtown street in 1916.

This photograph of wagons at the railroad tracks dates from *c.* 1916. The buildings in the background are, from left to right, Hope Mill, Granite Mill, and Swanknit.

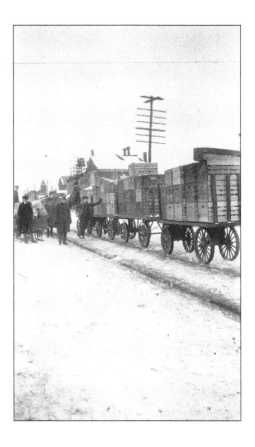

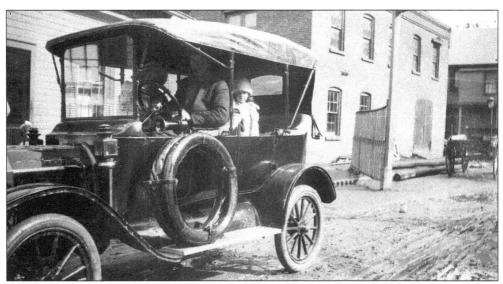

This family cruises in their nearly new (*c.* 1912) brass-era Model T Ford. Note the accessories that this owner had added, such as the mounted spare tires, covers, and the hand-powered klaxon horn.

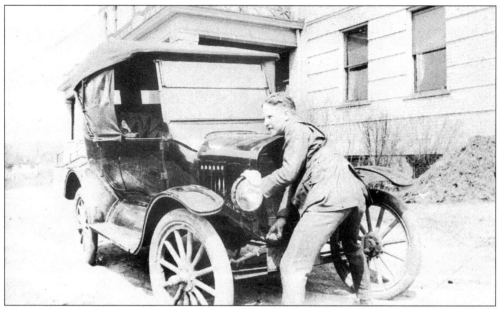
This 1915 view shows a gent starting his Model T the old-fashioned way: with a hand crank. Note the fabric windows on the side of the car and the shaded front windshield.

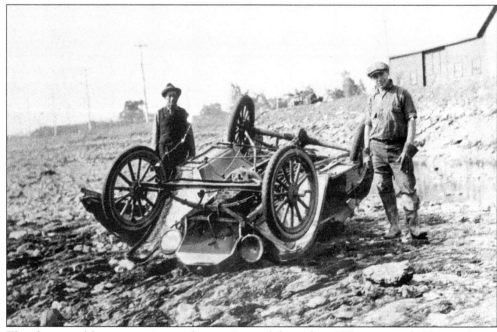
This driver and his passenger were having "one of those days." They are probably wondering what they can do to salvage this badly crushed Model T truck, which ended up in the power canal bed. The truck probably dates from the years just before 1920.

The conductor of the No. 209 trolley, which ran between Cohoes and Albia, is taking a cigar break while he waits for his next scheduled run. At the peak of operation of trolley cars (1923), they were so widespread that it was said to be possible to travel by trolley from the Capital District to Chicago by means of adjoining lines, with a 20-mile exception near Fonda, New York.

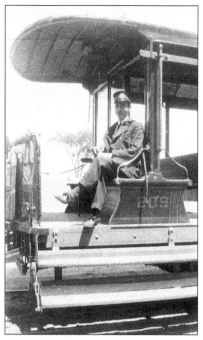

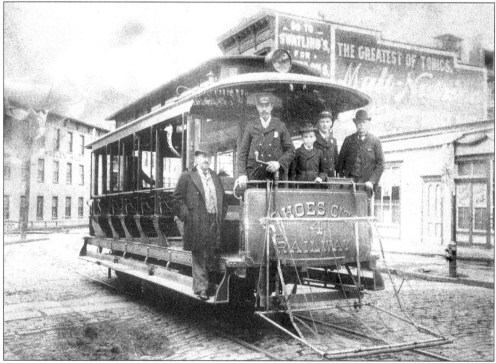

Horse-drawn streetcars linked Cohoes and Waterford as early as 1863, when the Waterford and Cohoes Horse Rail Road Company was established. The trolley car line joining Cohoes and Waterford opened in 1884. Its cars were painted green to differentiate it from the red line (between Waterford and South Troy), the white line (from Troy through Green Island), and the blue line (connecting Cohoes and Lansingburgh).

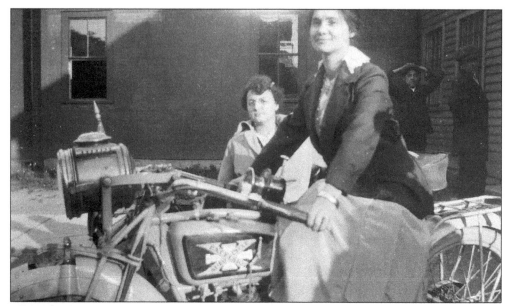

Albina Reil Plouffe poses on an Excelsior motorcycle built in upstate New York. The Excelsior motorcycle was a major competitor to the Harley Davidson Company until just after the stock market crash of 1929.

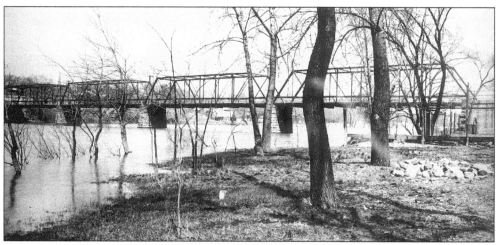

The old Bridge Avenue bridge is seen shortly before its replacement was begun in 1926.

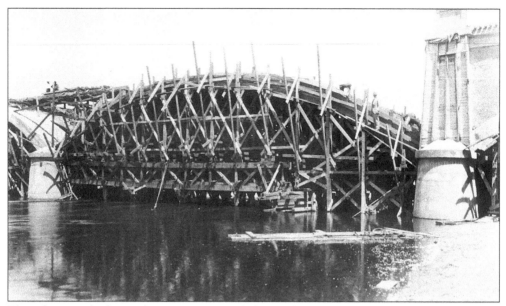

This photograph shows the construction of the Bridge Avenue bridge on April 10, 1927. General foreman Rudolph Ceccucci is pictured standing on the left, above the pier. Alongside is the contractor, T.F. Gratton. The two-by-six-foot studs used for the bridge forms were later used in building the clubhouse at Carlson's Pool.

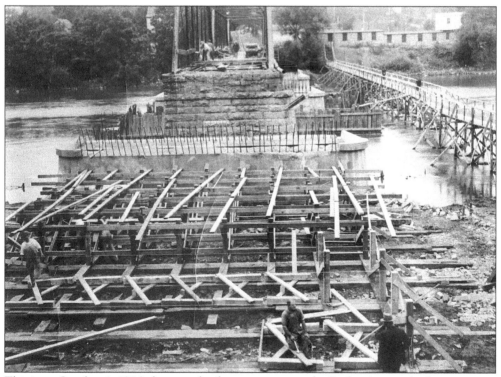

This is an October 4, 1926 photograph of construction on the Bridge Avenue bridge.

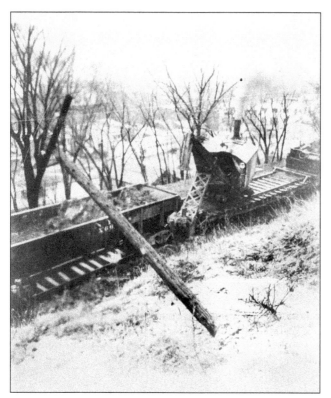

The New York Central Railroad was required to excavate and stabilize the hillside behind the carriage house of the William J. Dickey House in the 1920s. This photograph shows some of the work in progress. The treasurer of the Cohoes Savings Bank owned the house at that time. This track bed is now part of the Mohawk Hudson Bikeway east of Imperial Avenue.

The Delaware & Hudson (D & H) freight house is shown in this 1920s photograph. Note the two men standing in the first two loading doors. At the south end of the freight house is the coal pocket of the F.B. Peck Coal Company.

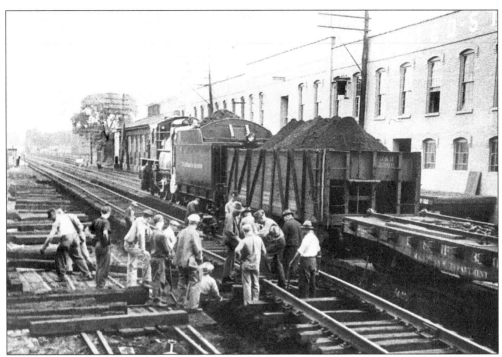

This 1933 photograph shows Big Jim Morello's D & H track gang working at the Cohoes railroad yards adjacent to the Star Woolen building on Saratoga Street. Big Jim worked his crews from Oneonta in the southern part of the line to the northern limits in Saratoga Springs and vicinity. During the years of the Great Depression, men were more than willing to undertake hard work along the railroad lines.

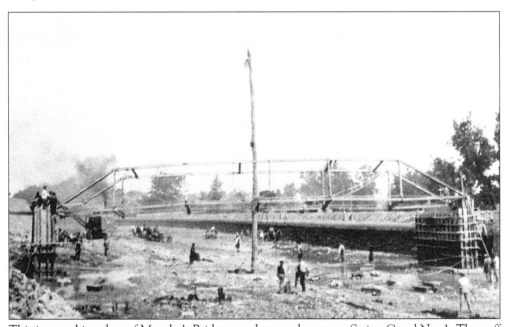

This is a working shot of Murphy's Bridge on what was known as Swing Canal No. 1. The puff of smoke to the left of the span is a steam shovel excavating the canal bed.

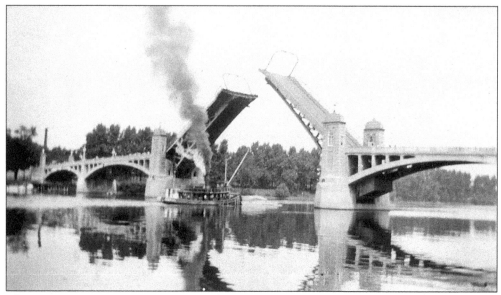

This *c.* 1935 photograph shows the 112th Street bridge spanning the Hudson between Cohoes and Lansingburgh. The first bridge at this location was built in 1880. During major reconstruction in the mid-1990s, the drawbridge—shown here open to permit passage of a tugboat headed to Matton Shipyard—was eliminated.

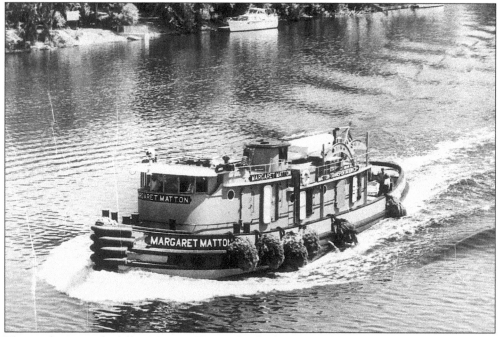

This tugboat was built by Matton Shipyard, which was established in 1902. The shipyard originally built and repaired wooden barges navigating the Erie and Champlain Canals. Matton's wood barges were considered among the best. At its peak (during World War II), John E. Matton & Son employed approximately 400 people and had a number of navy and army contracts to build submarine chasers, minesweepers, and tugboats. The company continued as a family-run operation until 1964.

# *Three*

# INDUSTRY

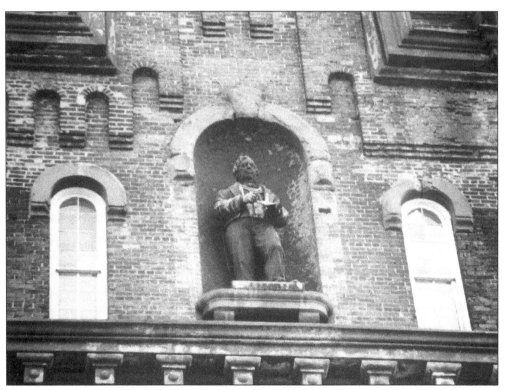

This bronze statue of Thomas Garner is located in an alcove in the central tower of Harmony Mill No. 3 on North Mohawk Street. Boston artist Martin Milmore did this larger-than-life sculpture. Garner, from New York City, and Alfred Wild, of Kinderhook, formed a partnership and purchased the Harmony Manufacturing Company in 1850. Soon thereafter, the Harmony Mills began a period of great expansion. The statue was installed in 1875, eight years after Garner's death.

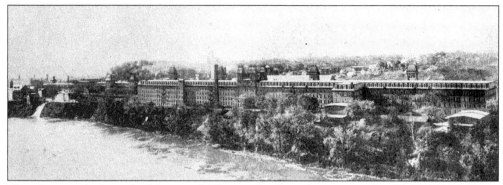

This photograph shows the Harmony Mills complex from the eastern side of the Mohawk River. Harmony Mill No. 3, constructed in 1866, dominates the image. The building was finished in 1872, making it the country's largest complete cotton mill at 11,856 feet long, 75 feet wide, and five stories high. It became the model cotton mill in the United States and was frequently visited by national and international manufacturers. The Harmony Mills complex is a National Historic Landmark.

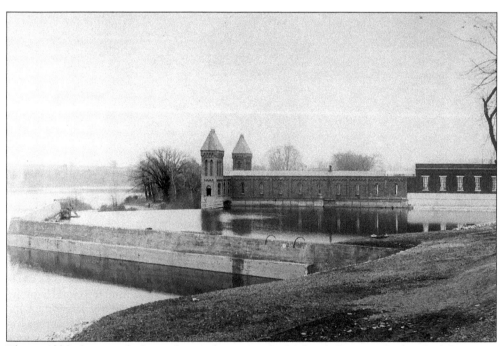

This c. 1920 photograph shows the gatehouse on the Mohawk River at the head of the power canal. The flow of water was regulated here to provide a reliable source of power for the mills.

32

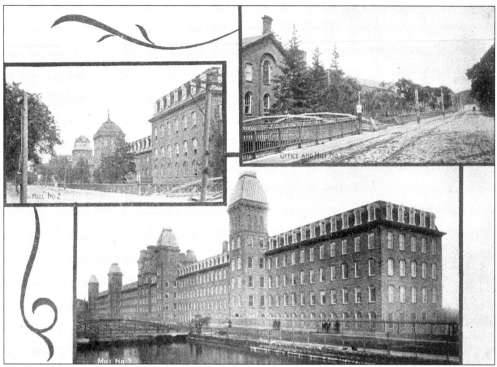

This photograph (with insets) shows Harmony Mill Nos. 1–3. A careful inspection reveals the canal and the footbridges that crossed it. This canal provided the water necessary to run the turbines that drove the machines located in the mills. Although the mills supplemented waterpower with electricity to ensure an uninterrupted power source to run the machinery, water continued to provide an ample means of cost-effective energy.

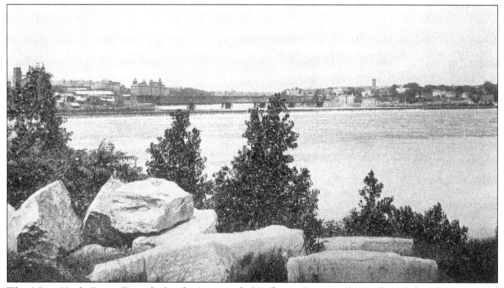

The New York State Dam helped to control the flow of water along the Mohawk River and ensured a regulated and sufficient supply of waterpower to the Harmony Mills, visible in the left background of this photograph.

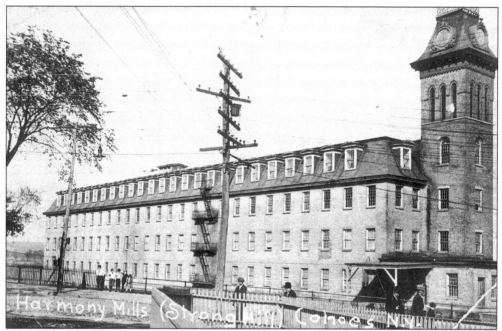

The Strong Mill was located at the present site of the Cohoes-Waterford Elks Club. William M. Chadwick built the mill in 1846. It had 2,700 spindles that supplied yarn for 80 looms. The mill consumed nearly 300,000 pounds of cotton per year and employed 69 people. A fire on July 8, 1854, destroyed much of the mill. It was rebuilt soon after and was purchased in 1865 by the Harmony Company.

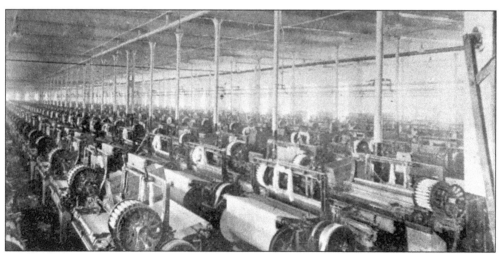

This photograph shows an interior view of one of the cavernous rooms of Harmony Mill No. 3. The multitude of looms permitted the mass production of fabric that made the Harmony Mills famous.

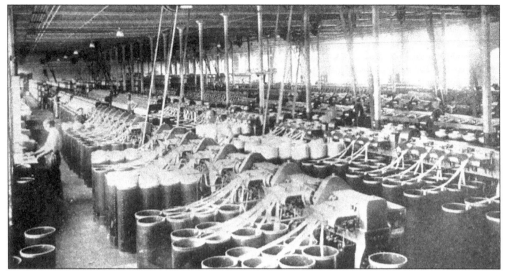

Harmony Mill No. 3 housed both drawing and roving frames. This interior photograph demonstrates that these mill buildings housed a large number of machines. Much of the work force consisted of young women who came to the mills to escape the tedium and toil of farm life. Some, no doubt, came to Cohoes to seek a young man as a future husband and provider; others desired more independence.

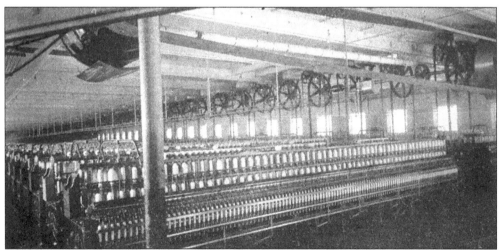

Harmony Mill No. 1 housed warp spinning machines. This interior photograph shows the array of spinning machines contained in this large open space. Imagine the noise that these machines made when they were all running and the potentially hazardous conditions caused by the exposed drive belts. Industrial accidents were common. Many workers lost fingers or limbs to the whirring machinery.

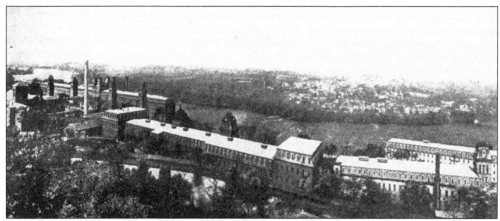

This is an overview of the Harmony Mills complex. The photograph was probably taken *c.* 1911 from Harmony Hill near Longview, the original name of the Johnston Mansion.

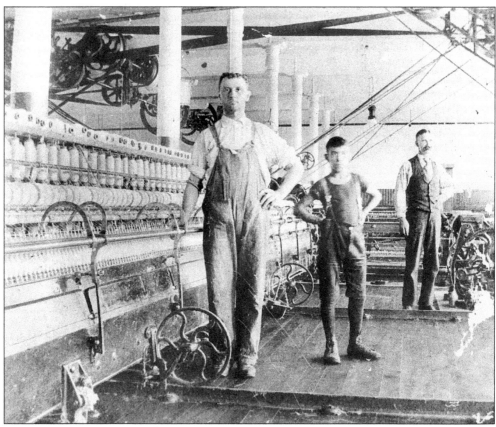

Workers in the Harmony Mills pose in front of machinery *c.* 1900. Children as young as seven were employed in the mills. They were paid considerably less than adult workers and were also valuable to employers because their small hands and stature permitted them to reach into machinery and access spaces that adults could not. Struggling families often depended on the additional income that child workers could earn.

The turbines inside Harmony Mill No. 3 converted the energy of flowing water to mechanical power to turn a system of belts to run the mill. This Boyden turbine was first manufactured in the United States and became the standard in the textile industry. In this mill, 13 miles of belts powered 2,700 looms and 130,000 spindles, producing 100,000 yards of cloth every 60 hours. This site is now a National Historic Mechanical Engineering Landmark.

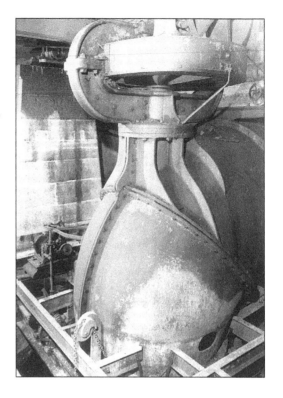

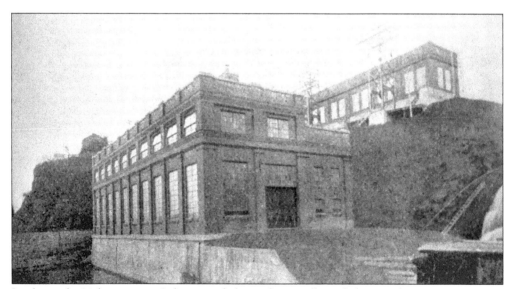

In the early 20th century, Cohoes used the Cohoes Falls and the canal system to produce electricity for the mills and for industry and residences in other parts of the city. Many homes built at the beginning of the 19th century were lit with electricity that came from this source.

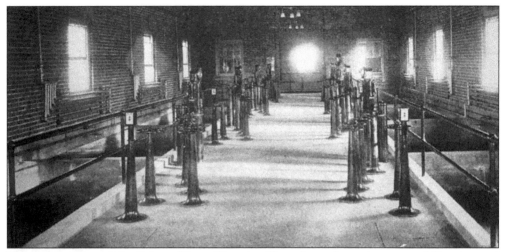

This interior view of the Cohoes Water Filtration Plant shows the early system of filtration and purification. Note the push-button switches on the stanchions in the foreground and the hand-controlled valves arrayed behind them. The lamps below the windows on either side of the room were used to give the operator a better view of the clarity of the water in these tanks.

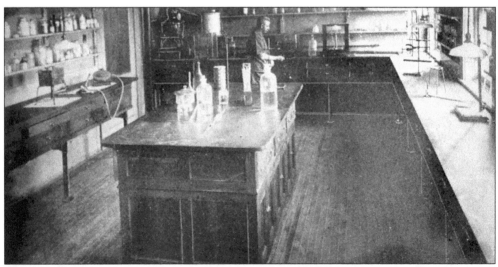

Each day of the week, a laboratory technician measured the quality of the water coming from the plant. In the back corner of the lab is a condensing unit, probably used to check for the level of particulate contained in the drinking water. A technician can be seen setting up a quality check at the back of the lab.

This view shows the canal after it was both widened and deepened. To achieve this change in the canal, the houses that lined it were moved back 40 feet. A new roadway was also added in the process.

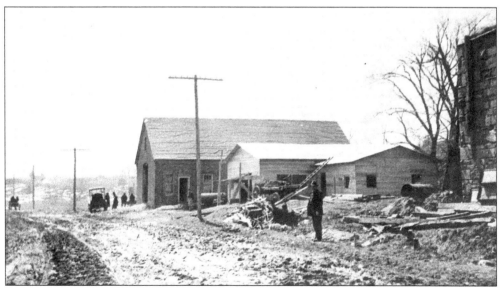

The site pictured in this 1912 photograph was east of the junction of River and Fonda Roads on the bank of the power canal. The brick wall on the far right is a remnant of a series of four locks of "Clinton's Ditch"—the original Erie Canal. With the enlargement of the Erie Canal in 1842, the single-chamber locks were abandoned. Today, only a few of the original stones remain, emerging from the hillside.

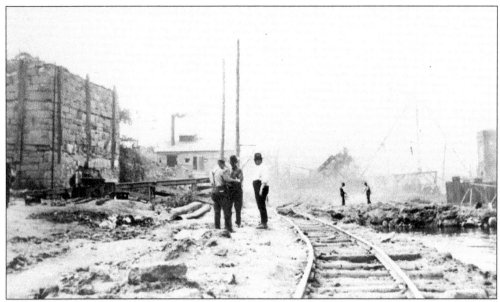

Workmen are shown c. 1912 at the gatehouse (near the intersection of River and Fonda Roads) during the canal-widening project. The stone structure on the left is a remnant of what once made up four locks of the old Erie Canal. The early locks were single-chamber locks, which severely restricted the flow of canal traffic. They were replaced by enlarged double-chamber locks in 1842.

Charles Potts is in the upper right in this group posing near the canal c. 1900. He was a mill worker who lived with his wife and nine children in one of the Harmony Mills' tenement houses on Willow Street. He began work in the mills at the age of seven. After years of various jobs at the mills, he worked his way up to loom fixer.

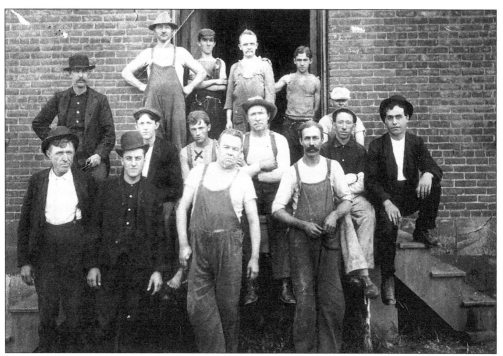

Cohoes factory workers gather for a portrait at the beginning of the 20th century. Marked with an X in the second row is Peter Lussier.

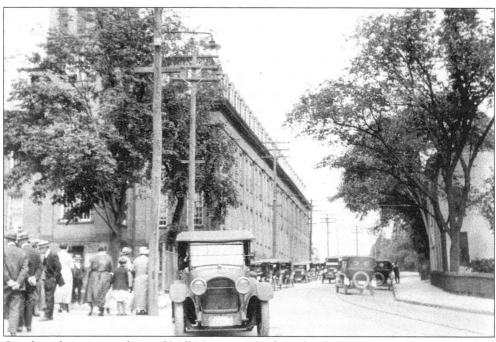

Cars line the street in front of Mill No. 4 on North Mohawk Street. Note the trolley tracks down the middle of the street and the dapperly dressed people on the left.

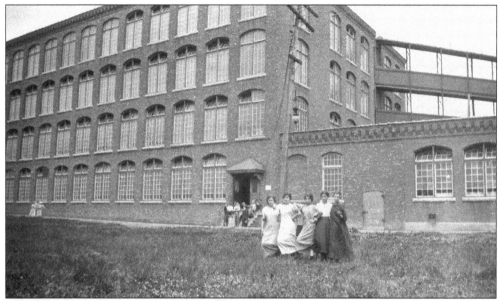

Some female workers take a break from their labors at the Kavanaugh Mill. A group of male workers rests on the steps in the background. Many Cohoes residents crossed the bridge to the Northside section in Waterford to work in the mills there.

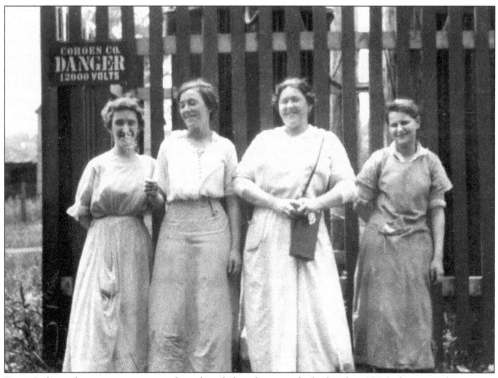

Four Cohoes factory women, on their lunch break, pose shyly for this 1926 photograph.

# *Four*

# BUSINESS

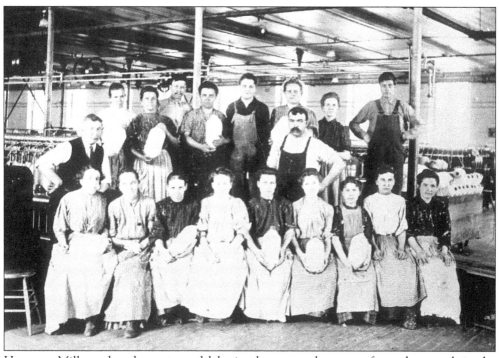

Harmony Mills workers have stopped laboring long enough to pose for a photograph in the factory's bobbin room in 1910.

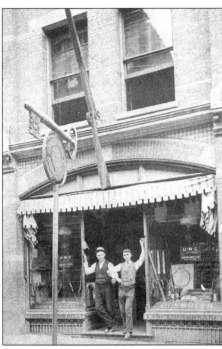

This photograph of Lackmann's Sporting Goods on Mohawk Street was taken *c*. 1900. Owner J. Leonard Lackmann is on the right.

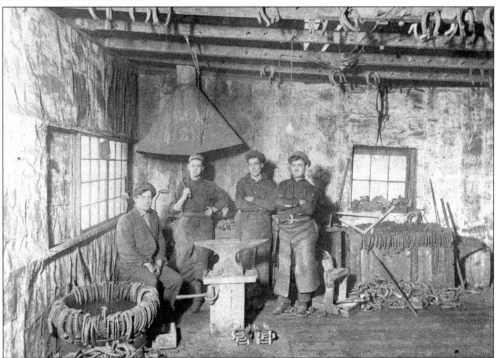

This photograph shows the interior of a blacksmith shop on Simmons Island, at Ontario and Clark Streets. The man seated is proprietor Alyre Baillargeon, who lived in the upstairs portion of the house with his wife and their eight children. With the growing popularity of motor vehicles, he was forced to give up his blacksmith business in 1925. The site is now occupied by a rental truck business.

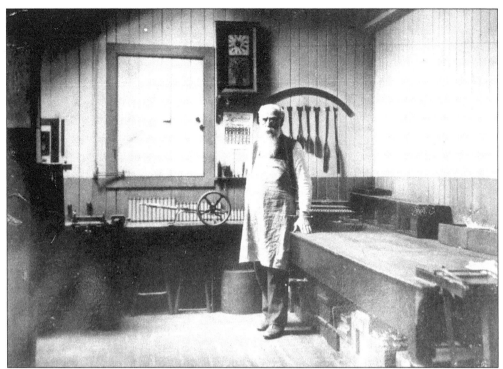

A late-19th-century artisan is shown in his woodworking shop, with the tools of his trade proudly displayed. These tools, including wood gouges, were considered state-of-the-art in the days when handcrafting was still common.

This snowy scene of North Mohawk Street, looking north, dates from *c.* 1872. Harmony Mill No. 3 is in the background. The Van Benthuysen Paper Mill, housed in the building on the left, was in operation in 1864. This building was sold to the Harmony Company in 1872 and was used for the manufacture of jute. The building on the right was the Cohoes Company office.

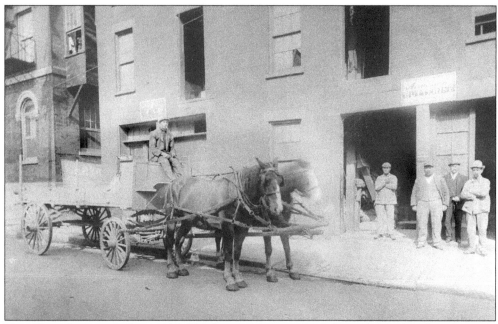

This 1900 photograph shows 297–301 Ontario Street, which housed a feed mill and storage facility. Waterpower derived from the canal adjacent to Peerless Fiber (on the left) drove the turbine in the basement of the building. Pictured from left to right are Joseph Guerin (on the wagon), ? Suprenant (in the doorway), Prosper E. Payette (with open jacket and cigar), Phil Payette (in the dark coat), and Joseph Davignon.

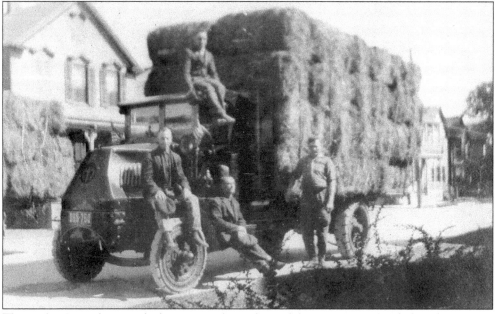

This early-1900s photograph shows several members of the Lajeunesse family by a hay wagon on a Cohoes street.

Oliver Roylance, assisted by grandsons William and Daniel, peddles vegetables *c.* 1870. Roylance, photographed in front of his home at 290 Vliet Street, was also employed at a nearby mill.

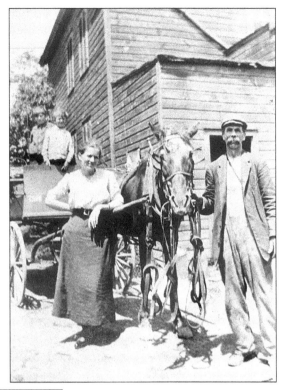

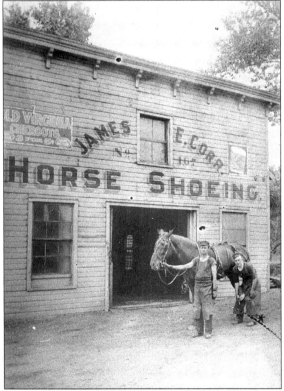

Edward Comtois shoes a horse at the James E. Corr blacksmith shop *c.* 1925. The shop was located at 167 Ontario Street. Edward's father, Felix Comtois, also owned a blacksmith shop from the 1890s to 1922, located at 109 Columbia Street. Horse-drawn vehicles continued to make deliveries to Cohoes residents through the 1970s.

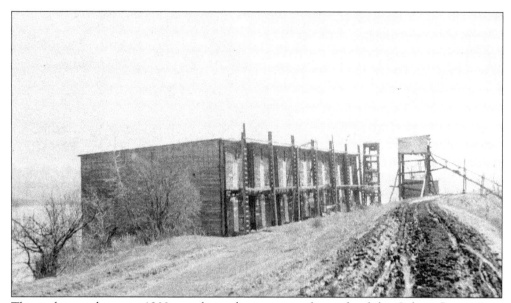

This icehouse, shown *c.* 1900, was located a quarter mile north of the Cohoes Power Dam on the west bank of the Mohawk River. Ice was cut and shipped by canal boat locally and to customers as far away as New York City.

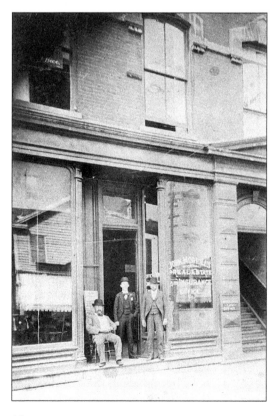

The office of John Morrill's Real Estate and Insurance, shown *c.* 1895, was in the Opera House Block on Remsen Street where the Cohoes Music Hall is located.

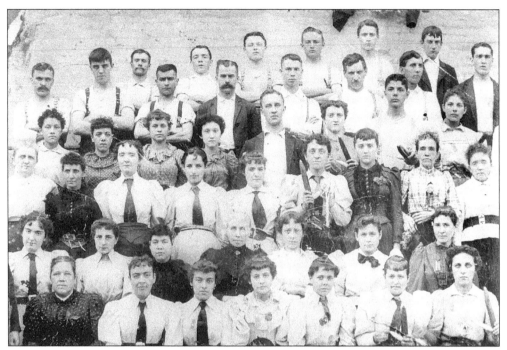

Mill workers, several of them holding the tools of their trade, pose outside the mill in this early-1900s photograph.

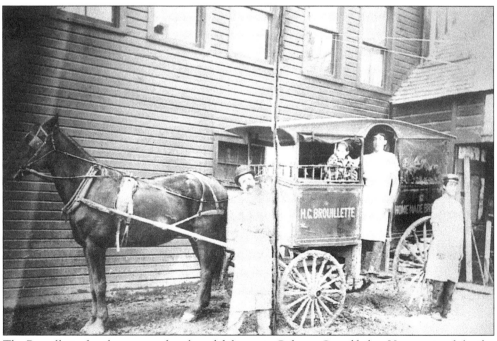

The Brouillette family prepares for a bread delivery in Cohoes. Grandfather Honore stands by the horse, with Walter in the wagon and Harry standing alongside it. The child is unidentified.

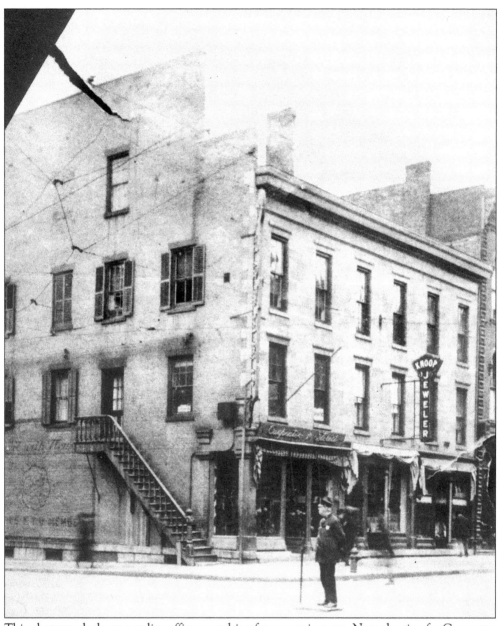

This photograph shows a police officer watching for oncoming cars. Note the sign for Carpenter the Florist, located at the intersection of Ontario and Remsen Streets. Also visible are the faint images of moving pedestrians.

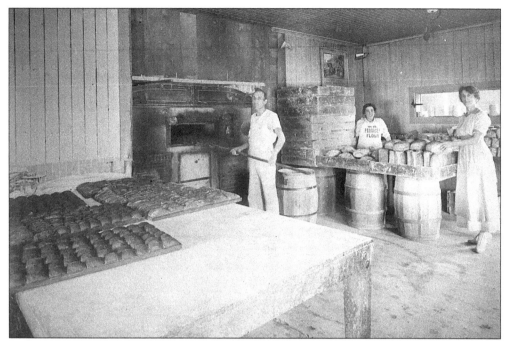

Bread is being baked at Brouillette's Bakery in 1906. Harry is tending the oven; Lena and Rita are working with the baked loaves.

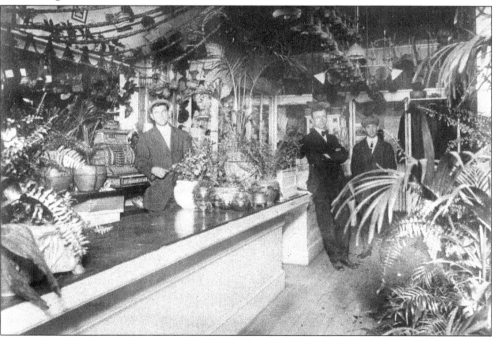

This *c.* 1909 photograph of the interior of Carpenter the Florist shows Dale S. Carpenter leaning against the counter. The Carpenters began their florist business in 1884, when Ansel D. Carpenter opened a shop on 74 Younglove Avenue. In 1909, the business moved to 59 Remsen Street, with beds at 248 Columbia Street. The business relocated to Columbia Street in 1929.

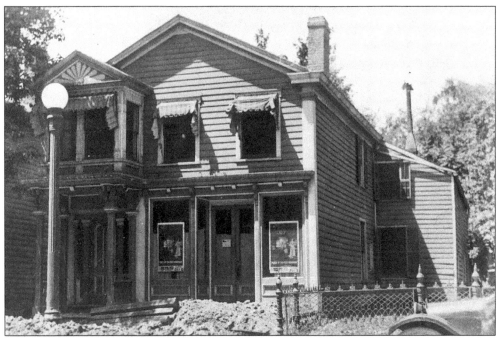

This is the original residence that stood at 142 Remsen Street next to the Cohoes Hotel. In the early 1920s, it was replaced with a new structure that housed Lackmann's Sporting Goods. It is now a vacant lot next to the hotel.

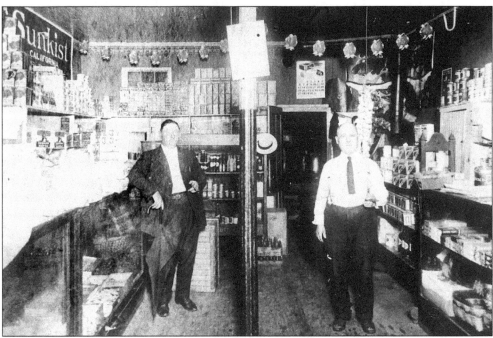

This fine establishment is Marra's Grocery Store, located on Remsen Street. On the left is Michael Tomaro, with Joseph Marra on the right. The store is a far cry from the large chains that Cohoesiers frequent today.

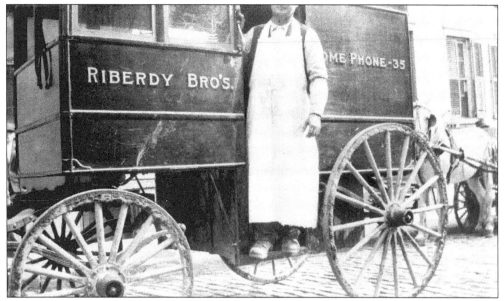

This 1920s picture shows the Riberdy Brothers delivery truck. The business was started in 1894, operated by Joseph Telesphore and Sinai Riberdy and located at the corner of School and North Mohawk Streets. By 1911, the store had moved to 69 Mohawk Street; in 1926, Joseph Riberdy opened a grocery at 166 Vliet Street.

In 1916, Cyril Berthiaume started selling ice, an important commodity in the days before refrigeration. This c. 1920 photograph shows the ice truck used by the Berthiaume Brothers for delivery.

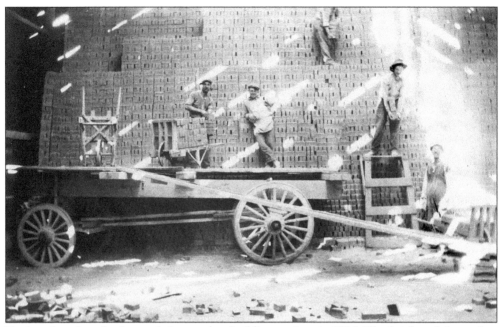

Brickyard workers load a truck for another building project in 1916. The brickyard, located at 45 North Reservoir Street, was part of William Murray's business operation.

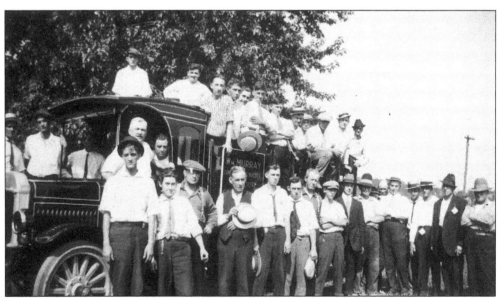

A group of workers poses in front of a William Murray truck in 1916. Murray was a contractor and builder who manufactured concrete blocks at 36 Devlin Street.

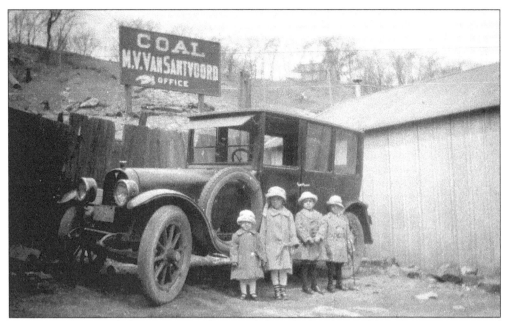

This 1919 photograph features a period automobile parked in front of the M.V. Van Santvoord Coal Company, located at the head of Factory and Remsen Streets. The fashionably attired children are, from left to right, Jeannette Plouffe, Albina Plouffe, Alfred Plouffe, and Alfred Patnaude Jr. In the background is Longview (the Johnston Mansion).

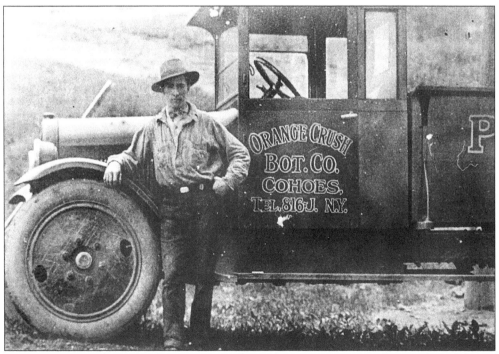

Shown c. 1930, a driver for the Orange Crush Bottling Company is ready to make a delivery. The company's owner was Almeida J. Bonenfant.

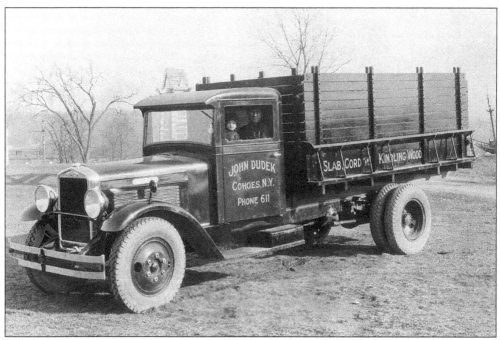

John Dudek Sr. is seated behind the wheel of this *c.* 1927 dump truck with his daughter Stasia. One month after the one-year guarantee on this truck expired, a piston went through the motor block, necessitating the purchase of a new $500 motor. Family legend has it that the Brockway Motor Company provided the new motor, allowing payment to be made when Dudek could get the money together. A handshake sealed the deal.

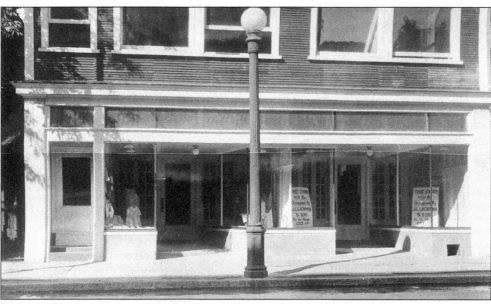

This photograph was taken just before the opening of Lackmann's Sporting Goods store at 142 Remsen Street in the early 1920s. Later this store became Smith Electric and, in the 1970s, a restaurant. It was destroyed by fire in the late 1970s.

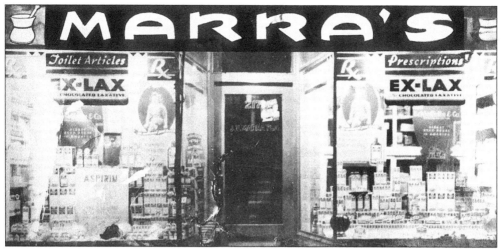

This is a 1931 photograph of Marra's Pharmacy. The Remsen Street family business is still in operation today. Earlier generations of the Marras had operated a grocery store on Remsen Street.

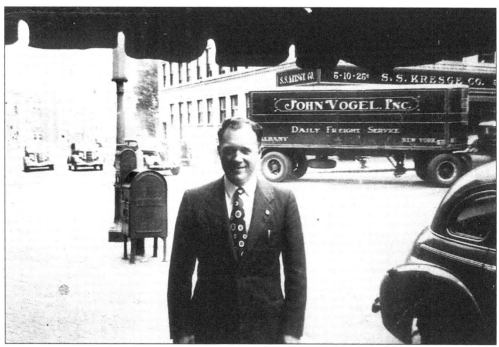

This image was taken on the corner of Remsen and Ontario Streets in the 1940s. Pictured in front of his business is John J. Donlon. Note the old S.S. Kresge Company sign and the John Vogel transport truck in the background.

Everyone pitched in when it came to the home-front effort during World War II. On this day, the Cohoes City Hall became the collection center for all sorts of scrap metal, which was recycled to help the Allies fight the war.

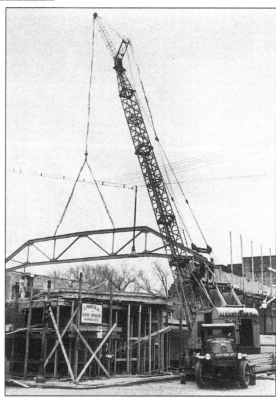

This 1941 photograph shows construction of the Cohoes Theater, on the corner of Remsen and White Streets.

*Five*

# WORSHIP

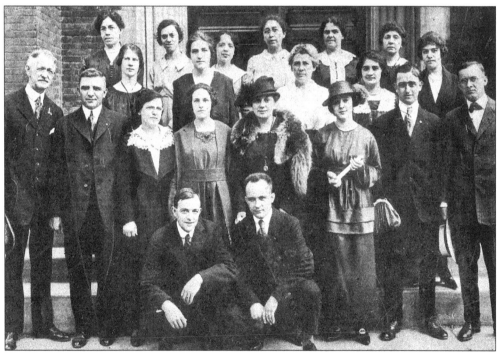

This 1918 photograph shows the choir of St. Joseph's Church. Only a few in the photograph have been identified. The man on the right in the first row is Edward Frament. The third person from the left in the second row is the wife of Henry Pellerin. The woman with the hat and fur collar is Gertrude Cohn. Sixth from the left in the second row is Agnes Dame.

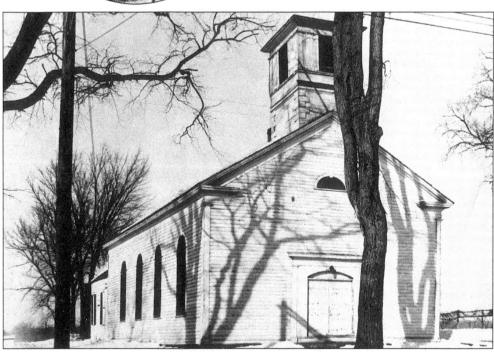

David Wilkinson founded St. John's Episcopal Church with the help of his brother-in-law Hezekiah Howe. The first church was built on Oneida Street and was consecrated on May 12, 1833. This image shows the second church, located on Mohawk Street. It was destroyed by fire on September 6, 1894.

The Reformed Church of the Boght was organized in 1784. The first pastor, Rev. John Damarest, preached in Dutch. English was introduced with the second pastor, a Dr. Bassett. A second church was erected in 1807; the one pictured here was built in 1847, about a mile west of the earlier church. The Boght refers to the area where the Mohawk River bends just before reaching Cohoes.

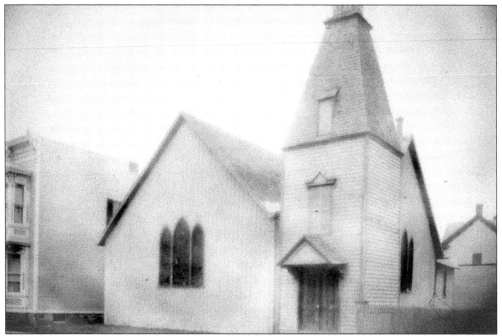

The history of St. James Methodist Church dates from the early 1870s, when a small chapel was built at the corner of Masten Avenue and Cherry Street. Around 1880, the congregation built this church to replace the chapel.

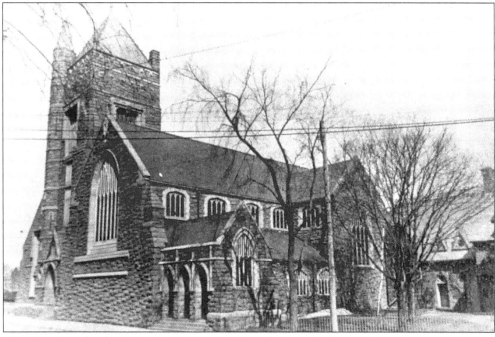

This church is the third St. John's Episcopal Church. It was built to replace the second church, shown on page 60. The cornerstone was laid on June 3, 1895, and the church was opened for services on April 22, 1896. The church was closed when the congregation moved to its fourth church building on Vliet Boulevard in 1970. This church is now the Cohoes Public Library.

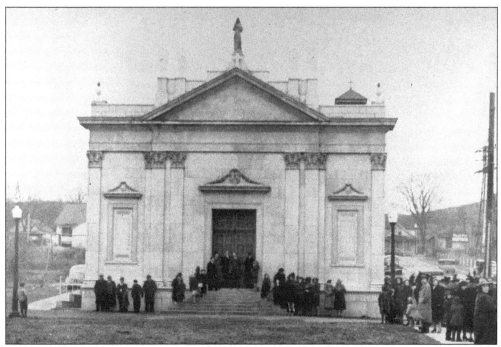

This exterior shot of St. Rita's Church was taken in November 1940, when Bishop Edmund Gibbons dedicated the church.

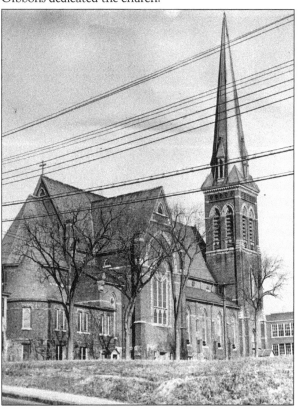

St. Agnes was founded in 1878. Its first pastor was John F. Lowery. The first church was destroyed by fire in 1883 and was replaced by the church that now stands. It is a city landmark. The steeple houses a fifteen-bell carillon, which was played every Sunday well into the 1950s. The church stands, as testament to the faith of past generations. Since being sold by the Albany Roman Catholic Diocese, it has returned to use as a house of worship.

The Dutch Reformed Church of Cohoes was organized in November 1838, and the cornerstone of the first church was laid that year. The church was torn down in 1859 to make way for a new church, which was dedicated in 1860.

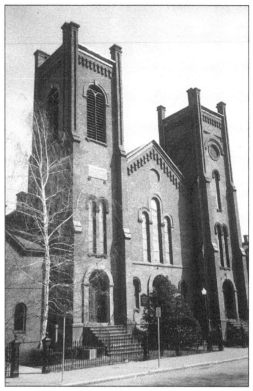

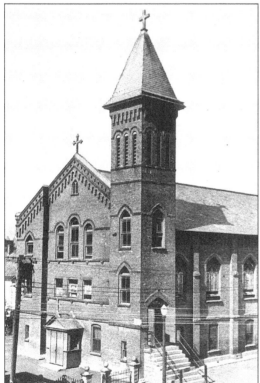

This is St. Michael's Church as it appeared in 1935. The first Polish immigrants came to Cohoes in 1901. In 1903, lots were purchased on Page Avenue as a site for a church. Eventually, the complex grew to include a school, a rectory, and a convent. The church cornerstone was laid on Labor Day 1904, and the church was completed in time for Easter services in 1905.

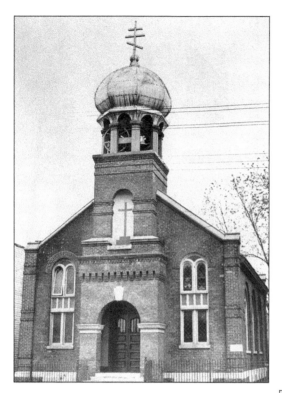

The Church of Saints Peter and Paul is a Byzantine Ukrainian Church belonging to one of the eastern branches or rites of the Roman Catholic Church. It was founded in 1907, with the church built between 1907 and 1908.

St. Joseph's was founded in 1868. The parish's first church was built in 1869, but it was feared that the weight of the steeple would collapse the church, so it was removed. The church was later demolished and, in 1874, the cornerstone for the present church was laid. The second entrance to the church, facing Congress Street, is on the left of this 1918 photograph.

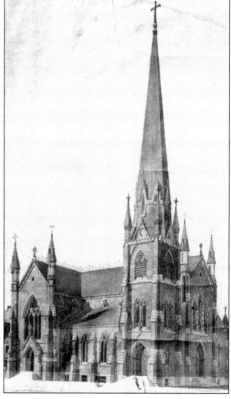

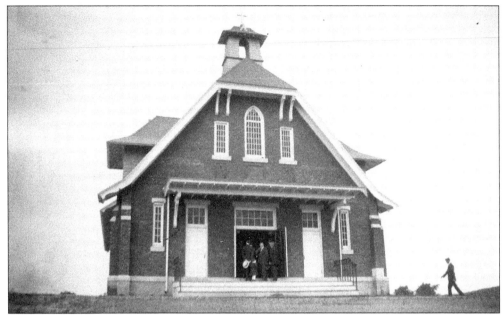

This is a 1915 view of a satellite church of St. Patrick's parish, located on Dunsbach Ferry Road. The building is now a private residence.

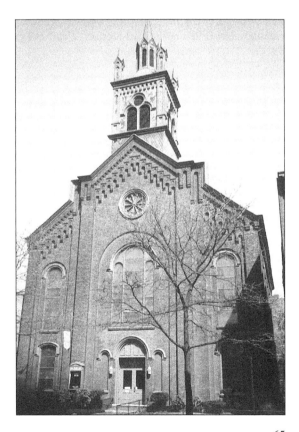

This 1990s photograph depicts the First Methodist Episcopal Church on Remsen Street, where Rev. W.W. Carr was the pastor. The church, with its grassy front courtyard, still stands.

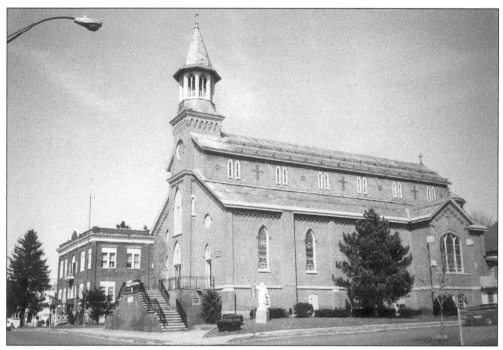

Sacred Heart parish, an outgrowth of St. Joseph's, was founded in 1887, with the first services held in an amusement hall on Jackson Avenue. In 1888, the church's first pastor, Eugene Rey, was named and the parish built a wooden chapel. The present church, a brick structure, was completed in 1899 under the direction of Father Lavigne.

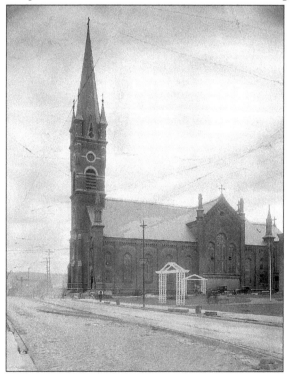

This photograph shows St. Bernard's Church with its second steeple, as the first one was destroyed in a severe storm during the winter of 1876. The nine-bell chime was destroyed and replaced by one bell. The present steeple dates from 1956–1957, when the church was renovated. During the renovations, the tower was lowered in height and a granite Celtic cross was put in place.

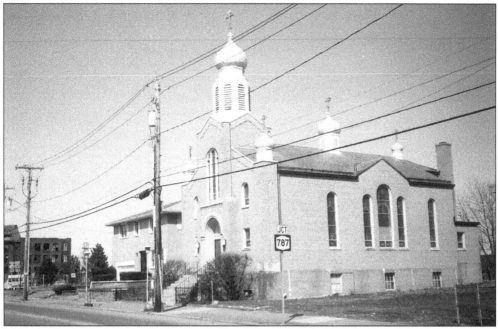

In 1913, two societies of Russian immigrants united to form the Russian Orthodox parish of St. Nicholas. The parish built a church on Saratoga Street in 1915. In 1941, this church was dismantled and the church that stands today was built. While the church was under construction, services were held at the G & G Potato Chip Company on the corner of Ontario and Saratoga Streets.

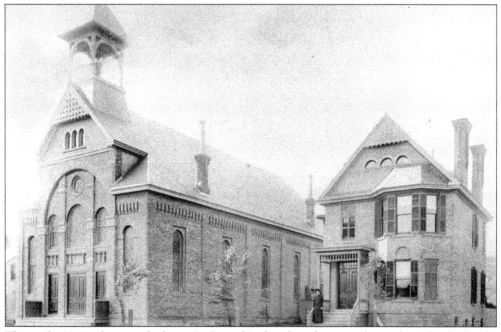

This early-1900s photograph shows St. Patrick's church and rectory, located in "the Orchard," on North Mohawk Street near the Harmony Mills. The buildings are now used by the Grace Calvary congregation.

*Left:* This unusual building on lower Newark Street was once the Assembly of God Church. The inscription "Chiesa Christiana Pentecostali 1848" above the door suggests that the church served Italian immigrants. Translated, this reads, "Christian Pentecostal Church." During the early 1900s, notices printed in Italian in the *Waterford Times* frequently announced coming missions and other events being held in this church. *Right:* This building, now a private residence, was once a synagogue. Jewish settlers came to Cohoes in the 1870s. The Jewish community of Cohoes founded the Beth Jacob congregation on August 25, 1896. In 1913, they acquired a structure at 294 Remsen Street and converted it into a synagogue. The building was sold in 1967, when synagogue members joined with the Beth Tephiloh Synagogue in Troy.

St. Marie's parish was founded in 1907. For a number of years, church services were held on the second floor of the parish school. The church shown here was opened for services in 1927.

*Six*

# EDUCATION

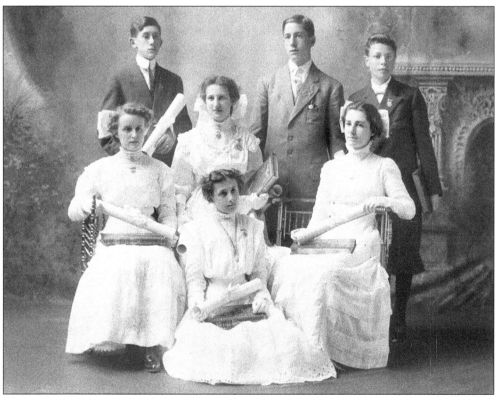

This is the graduating class from the business course at St. Joseph's School in 1909. From left to right are the following: (front row) Eva Lajeunesse; (middle row) Rose Alba Emond, Flora Augé, and Leila Mae La Vallée; (back row) Omer Palin, Leo Bechard, and Rudolph Blais. Most of the students and parishioners of St. Joseph's were of French Canadian descent.

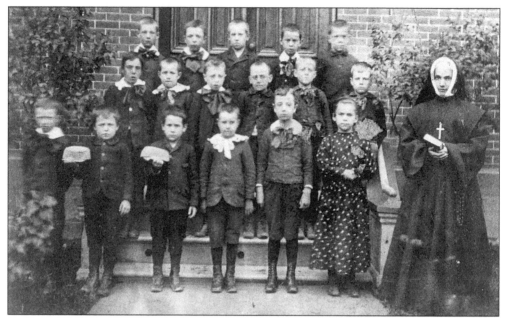

St. Joseph's School opened on September 8, 1880. Three hundred students were enrolled that year. There were two separate schools, one for the girls and one for the boys. The school buildings burned to the ground in 1901. This photograph was taken sometime after the new school was built in 1901.

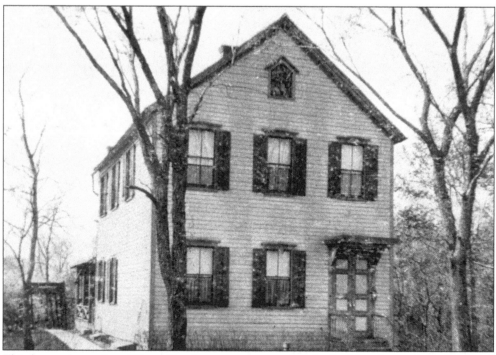

This house, located on Watervliet Avenue, was acquired by St. Marie's parish in 1916 and became the convent for the Sisters of Ste-Anne. The building, pictured here in 1931, is still standing.

This is the second St. Marie's school as it looked in 1931. It was purchased in 1916 to replace the first school, which had become too small to house the students.

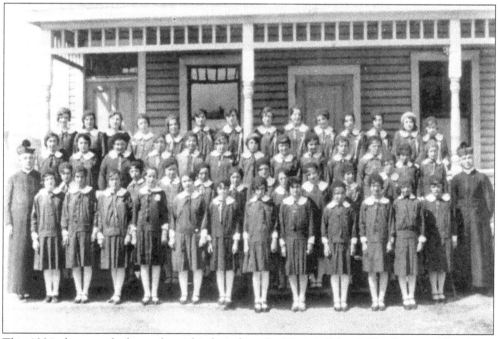

This 1931 photograph shows the girls' choir from St. Marie's School. The Sisters of Ste-Anne usually had one nun at their school who had been trained as a musician. She taught private lessons and trained the girls' choir. The choir sang at the students' service every Sunday. Except for the Latin of the Mass, the language used at the church was French, so the girls sang French hymns.

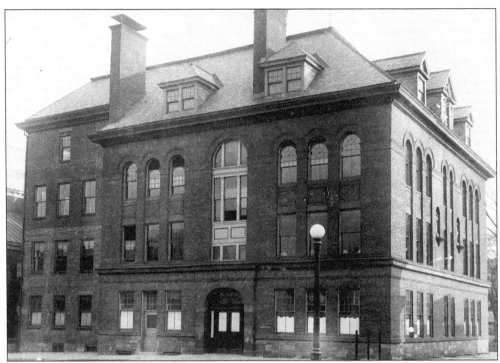

This is a 1920s photograph of St. Joseph's School, located at Lancaster Street and St. Joseph's Place. This was the second school serving the parish. The first school complex, consisting of a convent and schools for both boys and girls, burned in a disastrous fire in 1901.

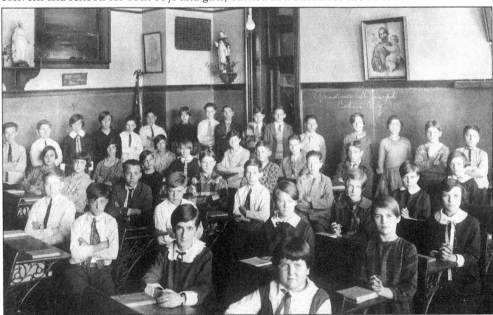

This *c.* 1920 photograph shows a classroom in St. Joseph's School. In the back row, third from the left with the white collar, is Olive Marie Comtois-Shawney. All the boys in the picture have their arms crossed and all girls have their hands clasped, under explicit instruction from the nuns.

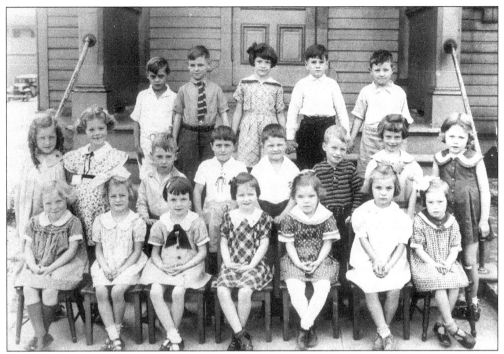

This 1937 photograph shows the first-grade class at School No. 9, located on Lincoln Avenue and Spring Street.

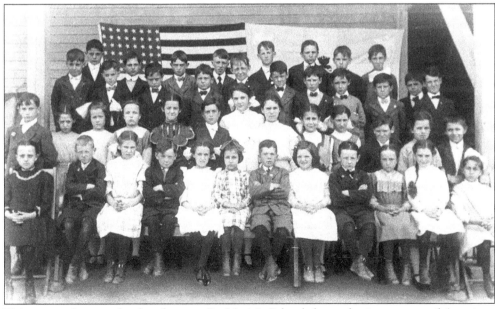

This group photograph of students at St. Marie's School shows the importance of American and French Canadian cultures to the school. The last student on the right in the first row is Leah Lajeunesse.

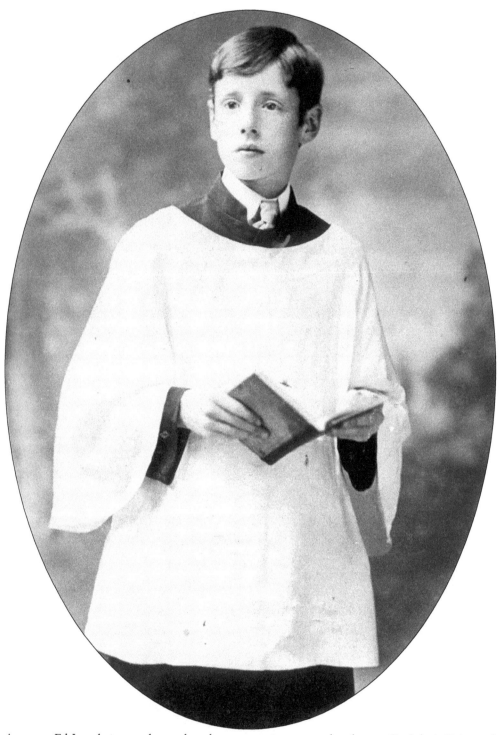

A young Ed Lynch is seen here when he was serving as an altar boy at St. John's Episcopal Church, *c*. 1910.

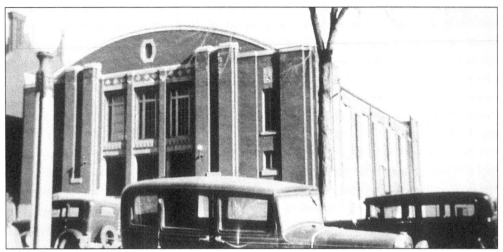

A lineup of early-1930s automobiles is out front of the St. Agnes Church Lyceum. The Lyceum contained a basketball court, as well as a bowling alley in the basement, where you had to set the pins by hand. The building is now used as a school of dance.

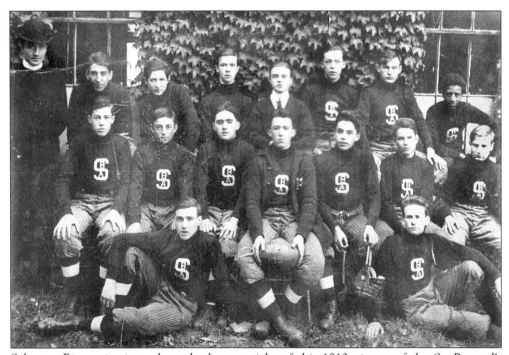

Sylvester Rigney is pictured on the bottom right of this 1913 picture of the St. Bernard's Academy football team.

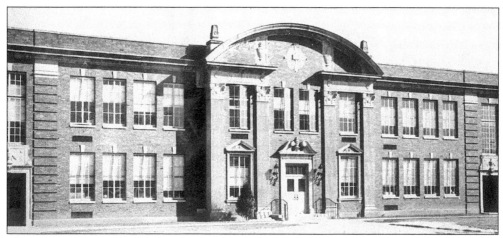

This is an early image of the Van Schaick School, the only public school on Van Schaick Island.

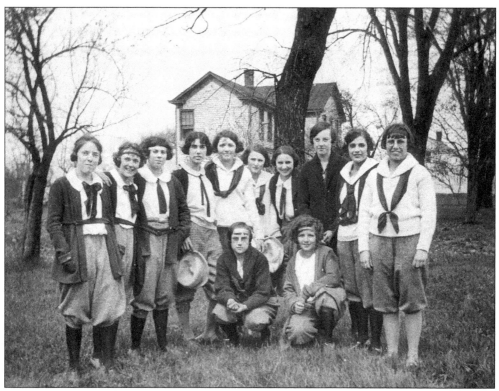

The St. Marie's Knickers Girls gather for a 1920s school portrait. Bobbed hair and headbands were all the rage, and some of these girls could not help but accessorize their school uniforms.

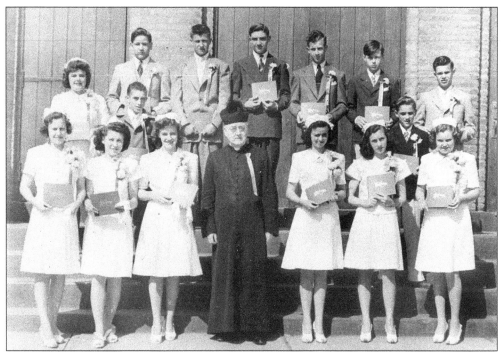

The 1946 graduating class of St. Patrick's School is shown with Rev. Thomas A. Flanagan, the pastor. From left to right are the following: (front row) Jacqueline Masse, Rose Mary Primeau, Jeanette White, Rev. Thomas A. Flanagan, Lois Elliott, Eileen Legnard, and Joan Rioux; (middle row) Catherine Peat, unidentified, and Albert Cyr; (back row) William Lecuyer, Francis LaPlante, Joseph Ruoto, John Durocher, Robert Craner, and Bernard Burns.

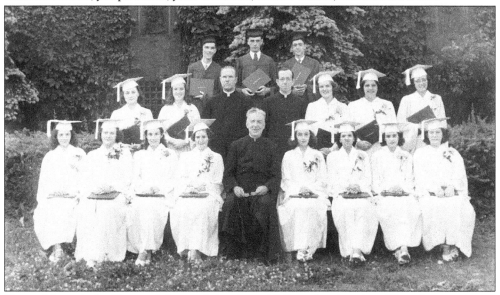

Pictured here is the Keveny Memorial Academy 1943 graduating class. The photograph was taken in St. Bernard's grotto. Note the preponderance of female students during wartime. In the front row center is Pastor Father Brennan. Keveny Academy continued to educate students until 1986, when it was closed by the Albany diocese.

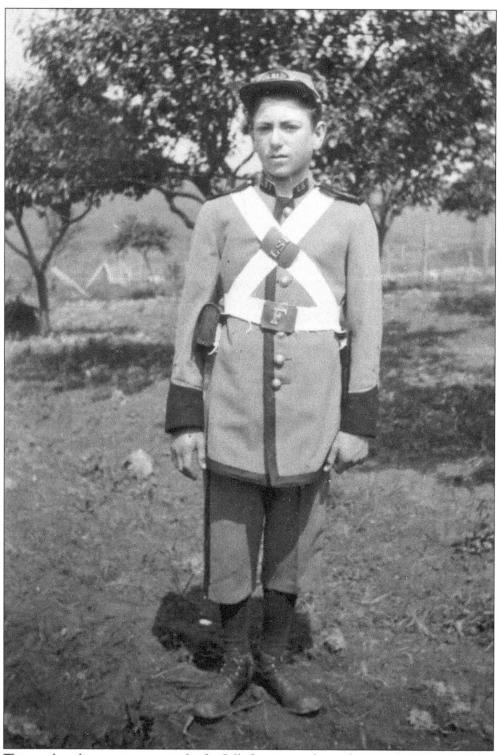

This youth strikes a serious pose in his La Salle Institute cadet uniform c. 1915. Note the long cut of his frock coat and the short pants.

# *Seven*

# PUBLIC SERVICE

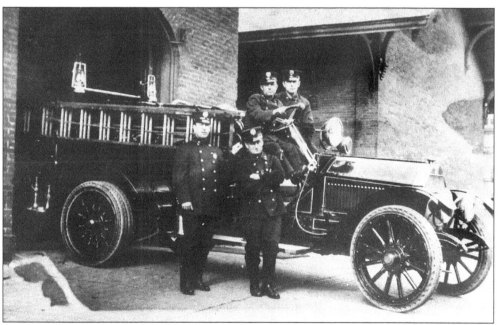

Four firemen pose with a fire truck in front of the Oneida Street firehouse in 1918. The firehouse was closed in 1967 and was then used for a time by the city's department of public works. The site is now a parking lot.

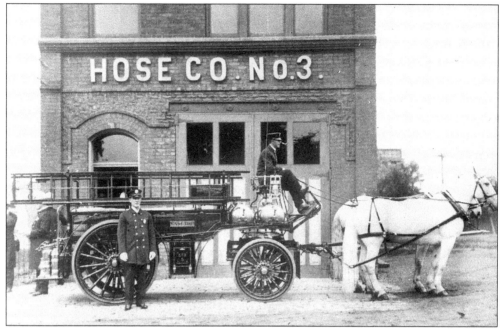

The Cascade Hose Company No. 3, on Washington Avenue, was built *c.* 1897. The Island section of Cohoes had no firehouse before this time. The two men with the wagon were paid firefighters; the others were volunteers for the fire company. This was the last firehouse in the city with volunteers on the force.

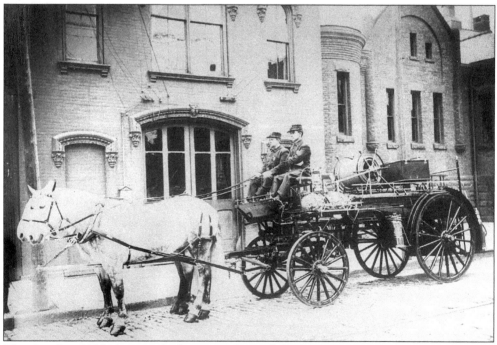

This October 1906 photograph shows members of the J.D. Leversee Hose Company No. 1 manning a fire vehicle drawn by two handsome horses. The firehouse was located next to the city armory on Main Street.

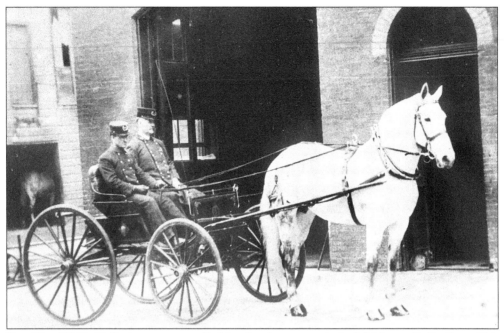

Fire Chief T.C. Collin's wagon is pulled by the department's faithful horse Dolly Gray. Bob Murray is the driver.

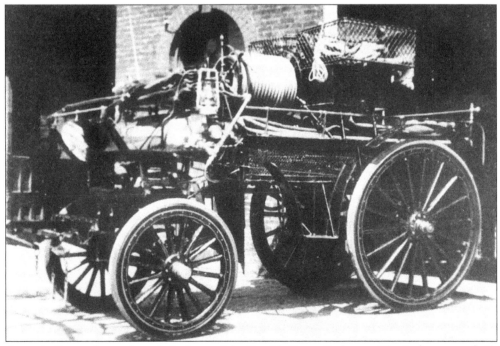

An early fire truck stands ready in front of the Oneida Street firehouse. The firehouse was built in 1867. The frequency of fires in the city's wood-frame structures ensured that the fire vehicles and fire companies were regularly engaged. There were five firehouses in the city at the time this photograph was taken.

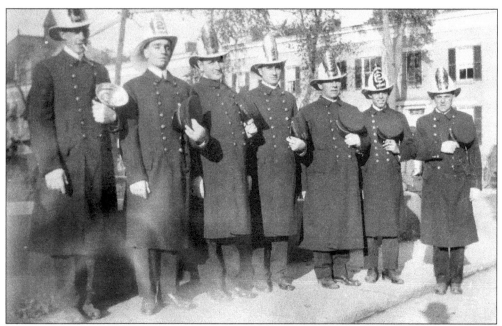

This 1916 photograph shows the Cohoes volunteer fire department. The last man on the right is Ludger Plouffe.

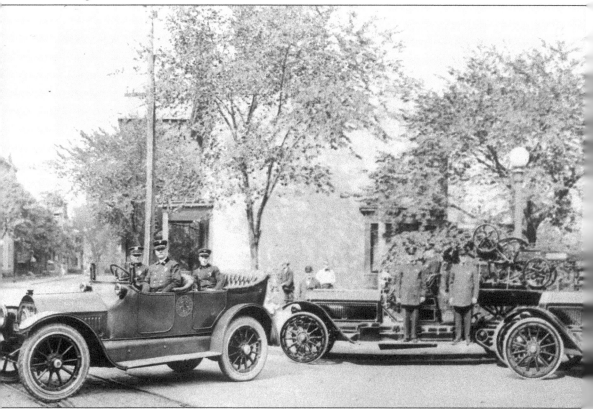

The entire platoon of the Cohoes Fire Department, in front of St. John's Church on Mohawk

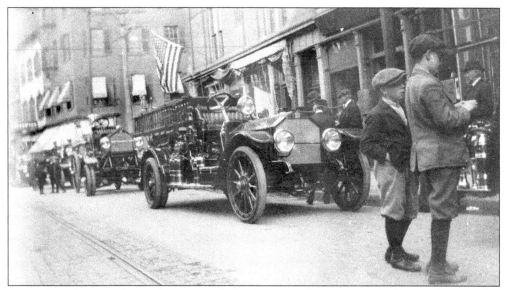

A parade up Remsen Street always provided a chance to show civic pride. Featured are city fire trucks, with spectators young and old looking on as they pass.

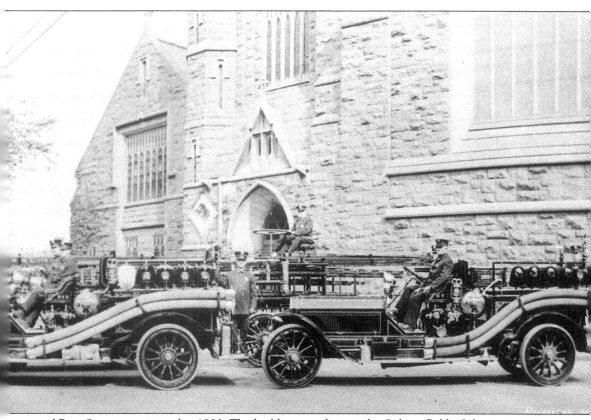

and Pine Streets, is pictured c. 1920. The building now houses the Cohoes Public Library.

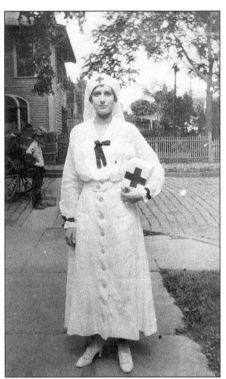

This nurse is appropriately attired for 1917. Here she poses outside with her Red Cross box in hand. Note the cobblestone street and the horse-drawn wagon in the background.

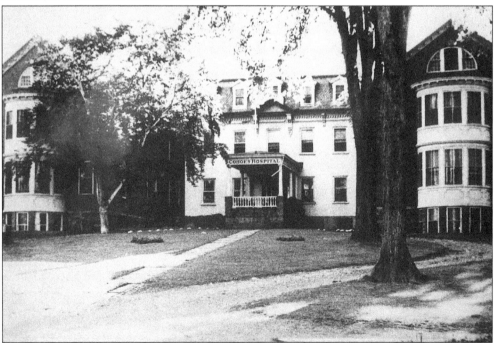

This is an early view of the Cohoes Hospital, then located on Main Street. This site, the former home of John Scott, was first used for the hospital in 1892. As needs increased, the two-story annex to the left of the main building was added. These hospital buildings served the city until the 1950s.

Soldiers pose in front of a guard shack in 1917. The shack was located at the end of Fonda Road, near the present Cohoes-Crescent Road. The soldier in the center is Alfred Patnaude, who gave his life in 1918 while fighting in World War I.

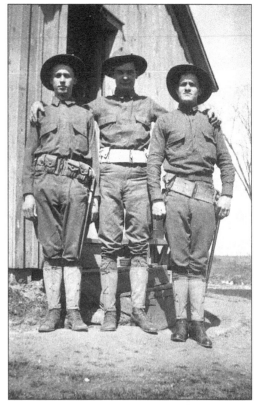

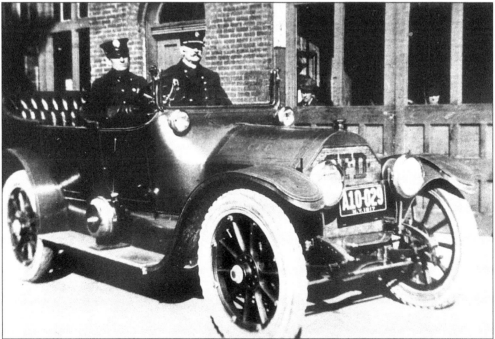

This 1917 vehicle parked in front of the firehouse on Oneida Street belonged to the Cohoes Fire Department. It was probably used by Fire Chief T.C. Collin.

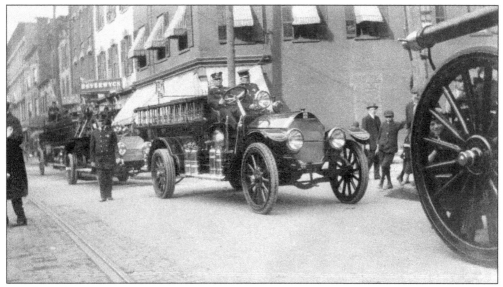

Parades of the past, much like those of today, included bands, local dignitaries, and opportunities to show off firefighting equipment. These vehicles—freshly washed, with their chrome polished for the occasion—were a point of civic pride for the community. This photograph dates from the 1920s.

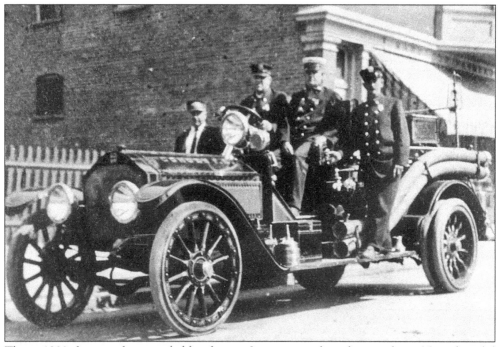

This *c.* 1920 photograph was probably taken in the same parade as the one above. Note the solid rubber tires on the truck and the evident pride of the firemen in their vehicle.

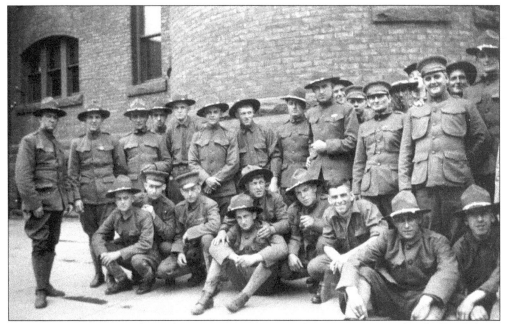

Soldiers pose in front of the Cohoes Armory in 1917 as the men prepare to head off to fight in World War I. The soldiers of the 27th distinguished themselves in battle, winning all types of U.S. military and foreign government honors for their valor.

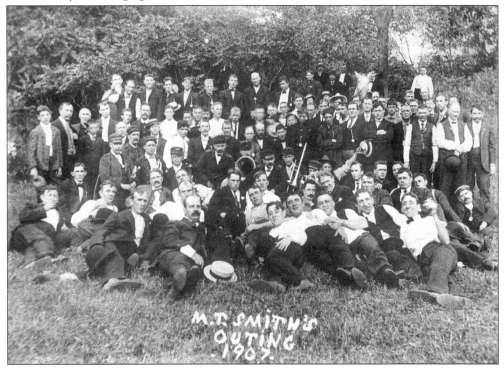

Politics was a very important aspect of city life, extending beyond smoke-filled rooms. Democratic Party boss Michael T. Smith organized social occasions and outdoor events such as this gathering for his associates and supporters.

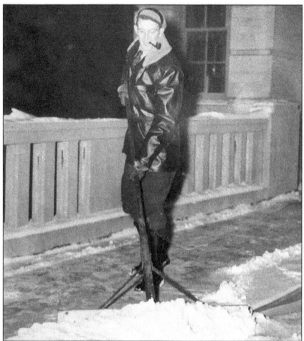

In this 1934 photograph, bridge keeper Edwin A. Willis shovels snow on the 112th Street bridge between Cohoes and Lansingburgh. The Bridge Company of Lansingburgh and Cohoes was incorporated in 1872, but actual building did not commence until 1880, when a span was built across the Hudson River connecting Ontario Street in Cohoes with 112th Street in Lansingburgh. This and other early bridges were built by private enterprises, and tolls were taken.

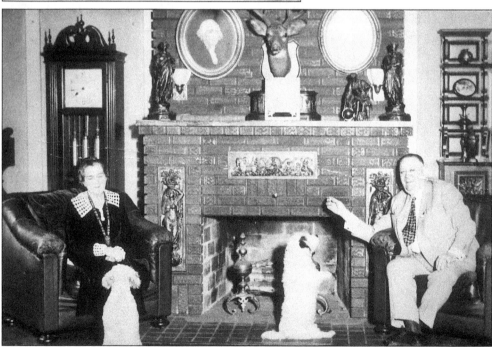

Michael T. Smith and his niece Patience Grey are at home on Hamilton Street in Cohoes. "Big Mike" was the undisputed leader of the Cohoes Democratic Party for many years, involved in Democratic politics at all levels. Although his Remsen Street establishment, Smith's Restaurant, was considered the unofficial headquarters for the Democratic Party in Cohoes, it is claimed that most political decisions during the era were made in the "Big House," his Hamilton Street residence.

*Eight*

# LEISURE

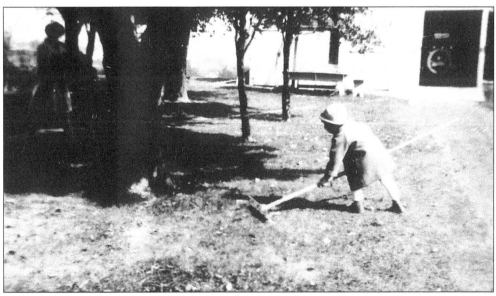

In this early-1920s photograph, George Coonrod is raking leaves in his backyard at 16 Imperial Avenue, the William J. Dickey House. Note the car parked in the carriage house, which originally housed a horse and buggy.

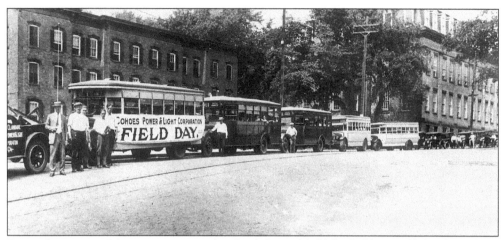

Pictured are some of the participants in the clambake and field day held annually by the Cohoes Power and Light Corporation. The vehicles are gathered on North Mohawk Street, with Mill No. 4 and workers' housing in the background. The Cohoes Gas Lighting Company and Cohoes Company became the Cohoes Power and Light Company in 1919.

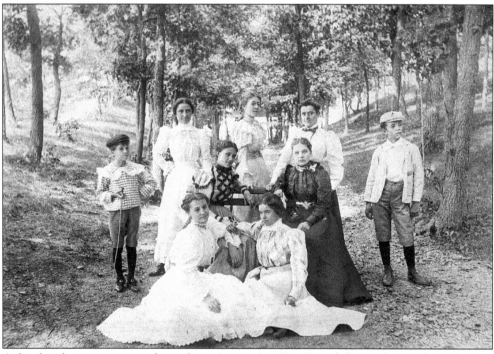

A family takes an outing in the park on August 9, 1898. From left to right are the following: (front row) Bertha Peltier and E. Bourfois; (middle row) Emelia Bourret and Vera Peichette; (back row) Roy Peltier, Emma Bourfois, Rita Peltier, Rose Granger, and Conrad Peltier.

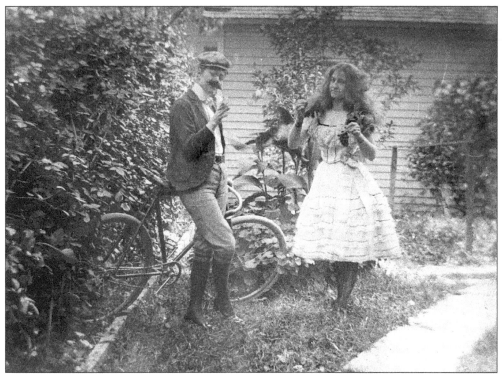

Rita Peltier, disguised as a mustached gent, poses with Bertha Peltier and a bicycle in the yard of the Peltier house on Congress Street, near St. Joseph's Church, *c*. 1890.

Lucille Baillargeon is sitting atop the horse. Standing are Beatrice (left) and Alma Baillargeon. They are three of eight children of Alyre and Maxima Targeon Baillargeon. This picture was taken at their home and blacksmith shop on Simmons Island off Ontario Street. Alyre's shop was located on the street level, and they lived upstairs. Maxima worked at a shirt and collar factory in Watervliet.

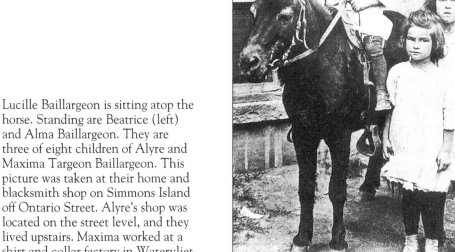

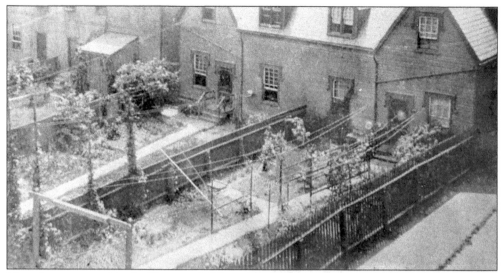

These houses, owned by the Harmony Mills, were rented to employees. The company's recruiting booklet advertised these garden spots. The houses were built with double masonry construction during the 1800s, in the heyday of mill productivity. They are still used as residences, a testimonial to their durability and a reminder of the city's industrial past.

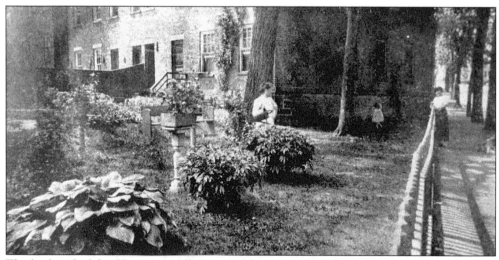

The backyard of this Harmony Mill Company house contains flourishing hostas, peonies, and rambling roses. A proud tenant is shown tending her garden in the late 1800s.

Two local bathing beauties, Marion Erno and Shirley Sullivan, pose in a backyard washtub in Cohoes.

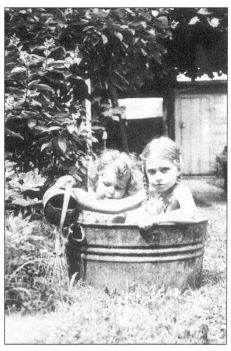

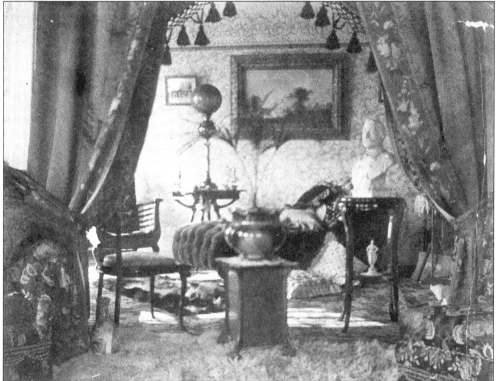

The Peltiers' parlor is captured in this photograph, taken prior to 1900. Decoration was everything to the well-dressed Victorian house, and this photograph is a great example of how too much was not enough.

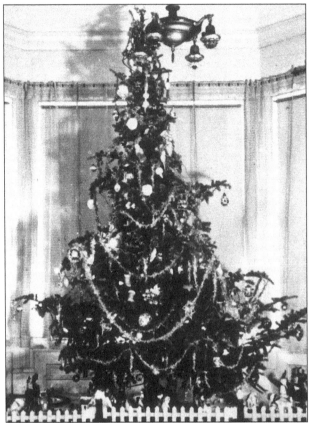

This photograph shows Christmastime in the 1920s at 16 Imperial Avenue (the William J. Dickey House), with the tree in the front parlor bay window. This tree was plugged into the hanging light fixture, and the fence surrounded all the goodies that had been received as presents. Note the miniature light bulbs on the fence. General Electric had only recently patented this design for miniature tree lights.

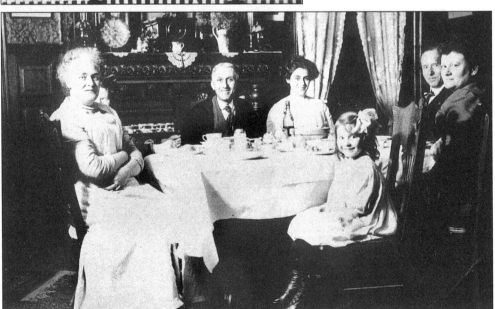

Dinner is the setting at the Lackmann home for this *c.* 1900 photograph. From left to right are Minnie Ostrander Lackmann, an unidentified guest, J. Leonard Lackmann, and Alice Lackmann. The three people on the right are not identified.

This photograph shows a group of St. Marie's parishioners at a get-together on a summer Sunday afternoon in the 1930s.

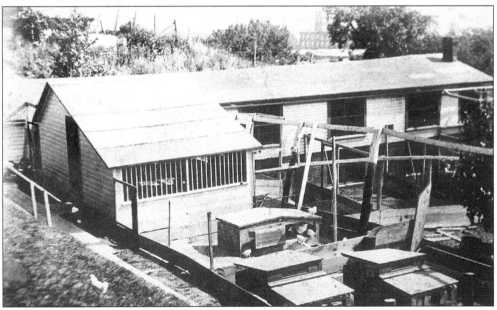

A late-1800s photograph shows chicken coops behind the Lackmann house, at 26 Imperial Avenue. During this period, many city families kept chickens and other small animals for their own food, or occasionally as an additional source of income. In the background is the Victor Knitting Mill, at 100 Ontario Street. The Lackmann family still occupies this house, which is on the State and National Registers of Historic Places.

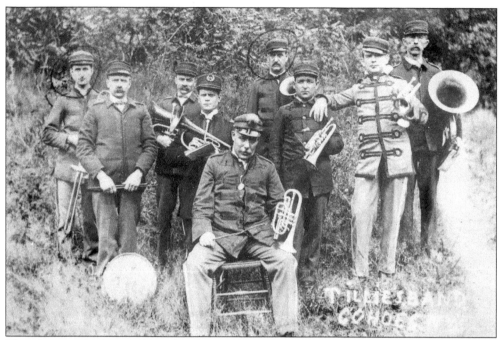

This photograph shows a brass band from the early 20th century. Nearly every town had a band that played at community events. Most bands used brass instruments, since the sound of woodwinds (such as flutes and clarinets) did not carry well in the days before amplification.

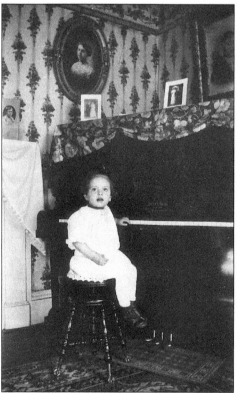

A child poses at the piano in a Victorian parlor. Making music was an enjoyable means of entertainment for many families of the period, but this little girl needed to wait a few years before she could reach the pedals to play.

Two women are shown riding sidesaddle on a
1920s Excelsior motorcycle. Imagine the thrills
riding this monster, built only for speed, with
"suicide" shifter on the gas tank, foot clutch, and a
hand-operated klaxon horn to warn unsuspecting
passers-by.

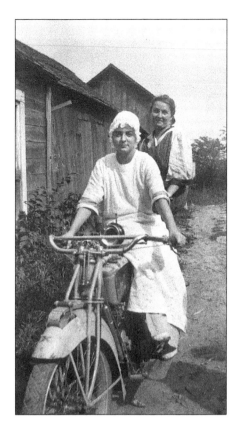

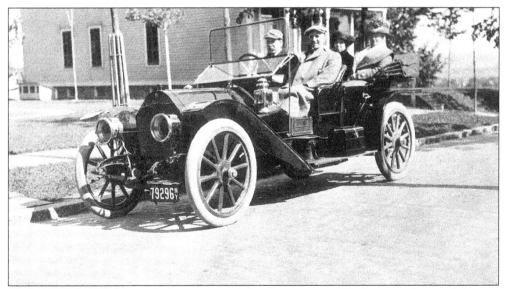

This group appears to be ready for an automobile adventure *c.* 1912. Posing on Imperial Avenue
are J. Leonard Lackmann (in the passenger seat) and his wife, Minnie (behind him). Note the
right-hand drive.

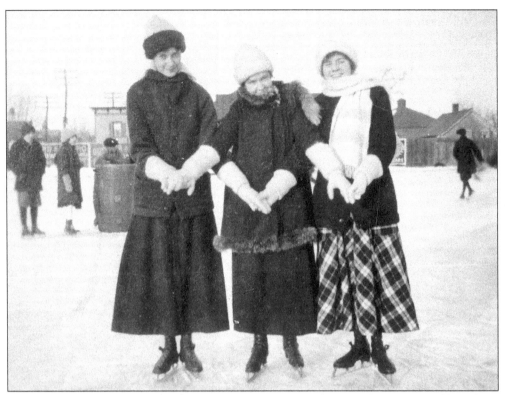

Three friends are seen skating c. 1912–1915. This was a posed shot, as the action could not have been captured with the average camera and film available at the time.

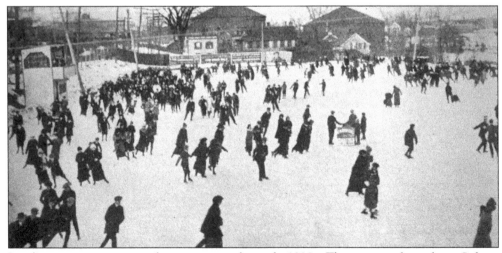

Ice-skating was a very popular pastime in the early 1900s. The system of canals in Cohoes provided many places for citizens young and old to enjoy skating on crisp winter days.

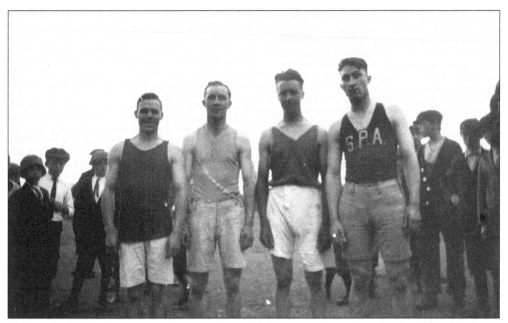

This early-1900s photograph shows track-and-field competitors from St. Patrick's Academy, with onlookers in the background. Athletes competed without the benefit of sophisticated shoes and equipment or the scientific training techniques common today.

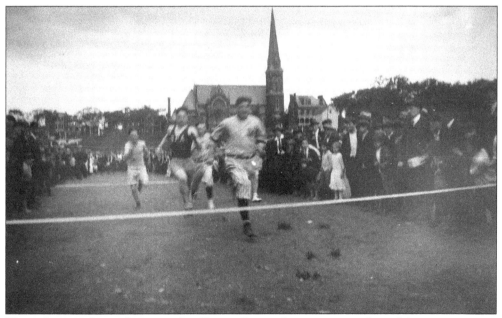

The polo grounds, on the east side of lower Garner Street, was a park used for many sporting events, including baseball, football, and footraces, as shown in this photograph. This site, bounded by St. Agnes Lyceum to the north and High Street to the south, is now occupied by the public housing community known as Roulier Heights, named after one of the city's mayors.

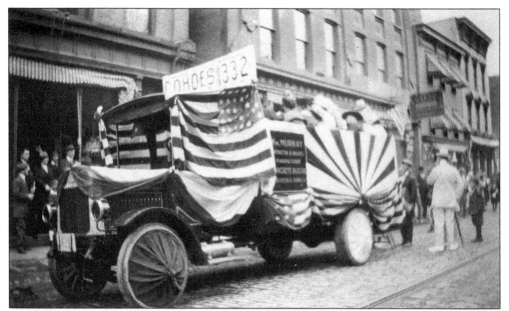

A bunting-draped Murray truck carries members of Cohoes Moose Lodge No. 1332 in a Remsen Street parade c. 1920. The Cohoes Moose Lodge No. 1332 was established on June 2, 1913, with the first meeting held in the rear of 232 Remsen Street. Today the lodge is again located on Remsen Street.

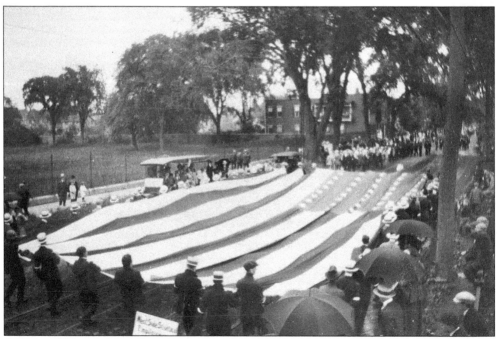

A group of West Side employees carries an enormous flag in a parade on a rainy day c. 1915.

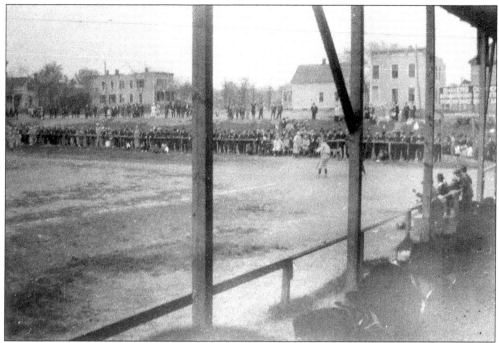

This baseball game took place at the Insular Grounds on Van Schaick Island in 1920. America's pastime was clearly popular in Cohoes at the time. Organized baseball is still played on the Island. Both intermediate and Babe Ruth League games take place at the fields off Continental Avenue.

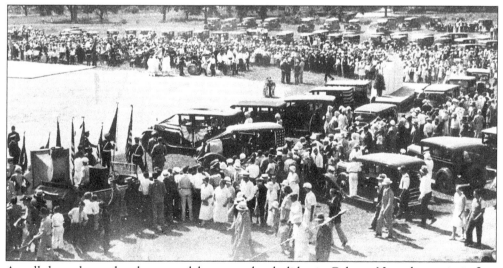

A well-dressed crowd gathers to celebrate another holiday in Cohoes. Note the patriotic flags and bunting on the 1920s cars.

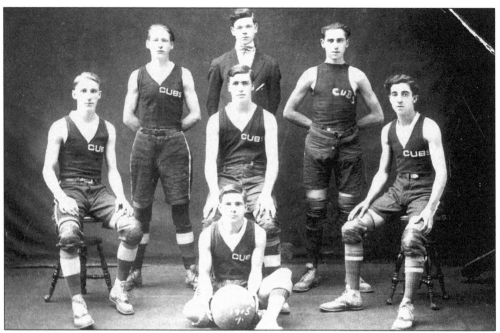

In this 1915 photograph, the Cohoes Cubs basketball team is sporting the latest in high-tech footwear.

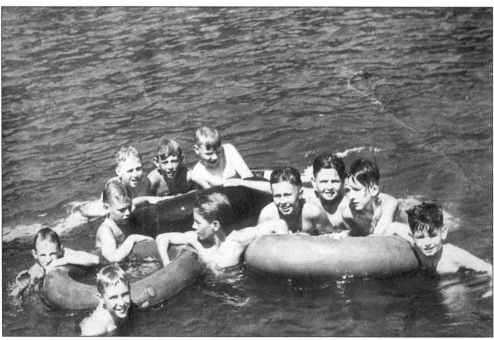

This group of boys enjoys summer fun at Carlson's Pool *c*. 1940. From left to right are the following: (top tube) Jack Finn, John McDonald, and Bob Finn; (between two front tubes) Jim McDonald; (right tube) Harold Rosecrans, Gary Glasheen, and Jack Glasheen. On the far right is Bob Glasheen. The rest are unidentified. Carlson's was a popular recreational area for Cohoesiers until 1974.

102

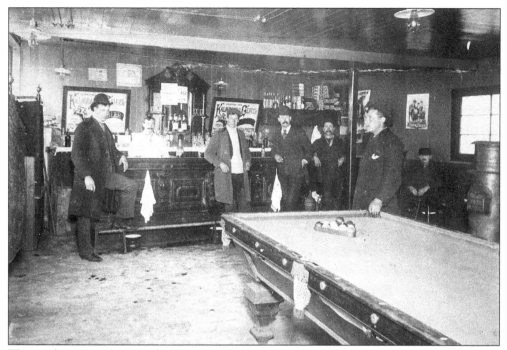

This early-1900s photograph shows a popular type of amusement in many communities, including Cohoes—the billiard hall. Note the long frock coats, the derby hats, the electric lighting, and the various beers advertised on the walls.

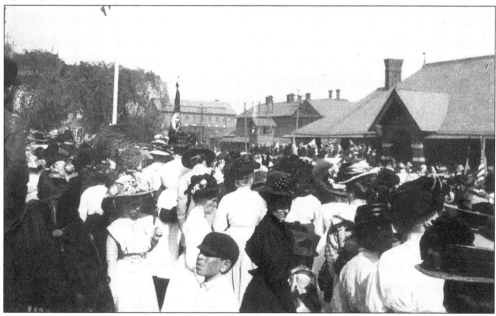

The French Canadians celebrated St. Jean de Baptiste Day with a five-division parade and horse races, games, picnics, dancing, speeches, and church services. On this holiday, all mills in Cohoes were closed and city businesses closed at noon. This photograph, taken at the train station in the early 1900s, shows people waiting for the arrival of dignitaries. Special guests attending city festivities included the governor of New York.

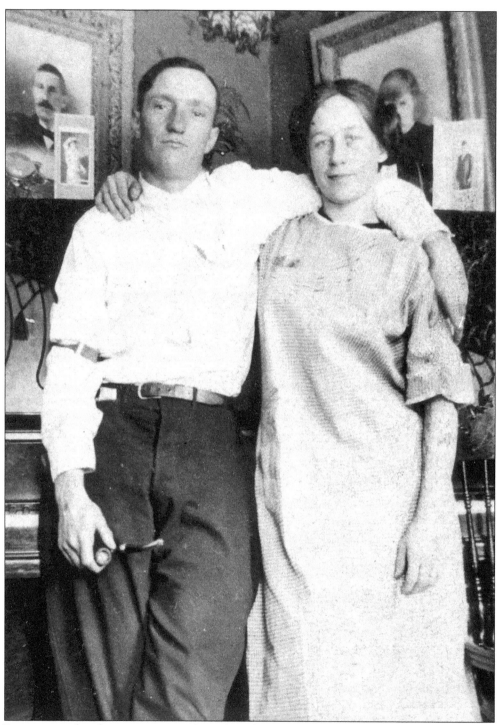

It was unusual to have an interior shot taken during the Victorian era, as the film was very slow and the lighting was poor. Anna and Peter Lussier are shown here posing proudly in their parlor. Note the family portraits and the piano, an item that many middle-class families wished to own.

# *Nine*

# PEOPLE

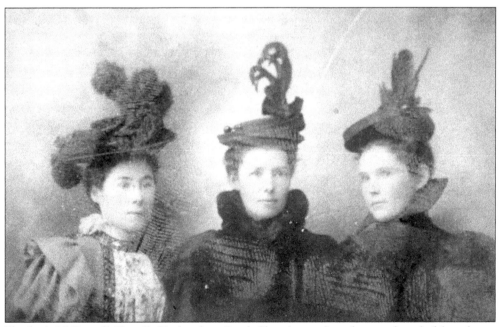

Elizabeth McDowell Shea (left), daughter Sarah Shea (center), and an unidentified friend pose in fashionable plumed hats *c.* 1898. The Union Photography Studio, the source of this picture, was located at 103 Remsen Street.

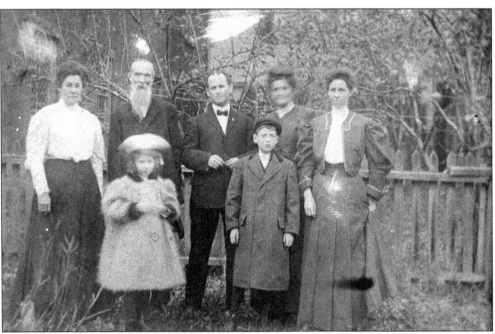

Abram Lansing, born in 1861, was educated in Cohoes schools and the Albany Academy. He graduated from Williams College in 1883 and was supervisor of music in the Cohoes public schools. He was the organist and choirmaster for the Fourth Presbyterian Church, directed the Cohoes Community Orchestra, and was a member of the Cohoes Musical Society.

Three generations of the Shea family pose in the fall of 1908 in the backyard of their home on 16 Walnut Street. From left to right are the following: (front row) Grace June and Edward J. Lynch; (back row) Elizabeth McDowell Shea; her husband, Dennis; and three of their four surviving children—Edward John, Agnes, and Sarah Jane.

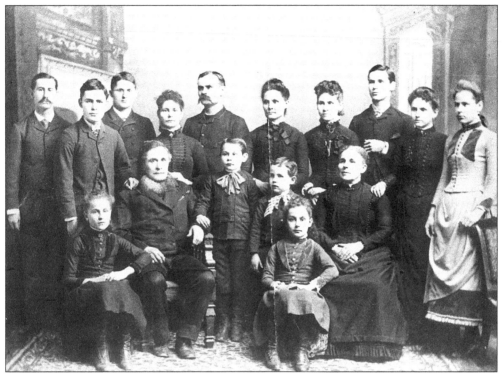

This 1900 picture shows the family of Louis and Clemence Lepp Favreau. From left to right are the following: (front row) Rosalie, Louis Sr., Edward, Arthur, Clara, and Clemence; (back row) Ferdinand, Joseph, unidentified, Denise, Louis Jr., Mary, Matilda, Napoleon, Lisa, and Exilda. The Favreaus were one of the many French Canadian families who were drawn to Cohoes to work in the mills.

George McDowell was a prominent Republican leader in the second ward, which encompassed Simmons Island and the area west into downtown. This photograph was taken in 1892. Although the Republican Party was dominant in early days of Cohoes politics, it was eclipsed by a strong Democratic Party machine (as was much of Albany County), and city politics were controlled by Democratic officeholders throughout much of the 20th century.

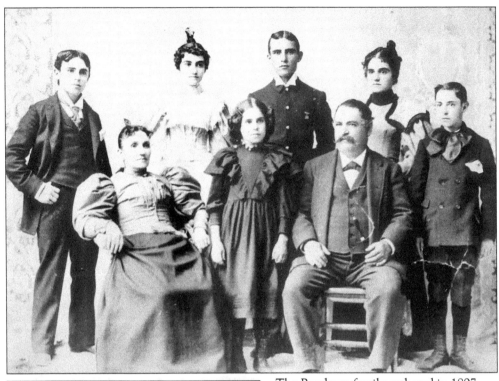

The Boudreau family gathered in 1897 for this formal portrait. Portrait studios always took these photographs. Kodak and its box camera made it affordable for the average household to take its own pictures at the beginning of the 20th century.

Portrait photographers often used props, such as this highly ornate wicker lounge. They provided the model with a comfortable place to rest for the long exposures required by the slow film of the day. These props added interest to what might have been an otherwise dull photograph.

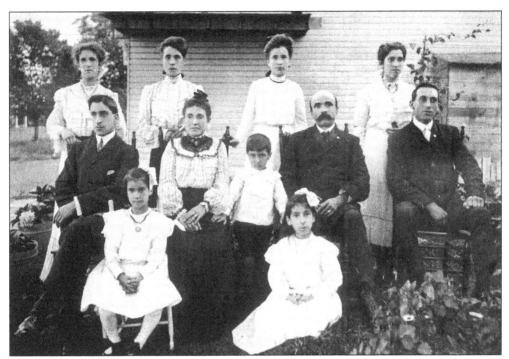

The Brouillette family poses outside their home and bakery business in 1906. From left to right are the following: (front row) Bertha and Eva; (middle row) Walter, Delphine, Raymond, Honore, and Harry; (back row) Rita, Laura, Clara, and Lena.

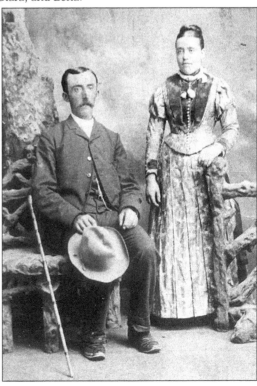

This photograph of John Donlon and his wife, Maria Cavanaugh Donlon, dates from c. 1872. Donlon opened a meat market on White Street in 1874. In 1884, he opened a grocery store on Younglove Street (renamed Devlin Street in 1888), which his widow and his son Richard continued to operate after his death. Richard formed the Donlon Insurance company in 1899. The studio at which this photograph was taken was located on Remsen Street.

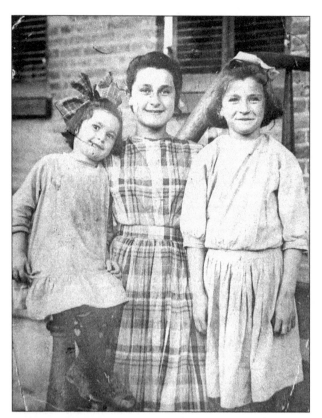

Three of the nine children in the Charles Potts family are seen posing on their porch at 68 Willow Street *c.* 1916. From left to right are Estella, Marinda, and Mary. Estella worked in the mills in the city and lives in Cohoes.

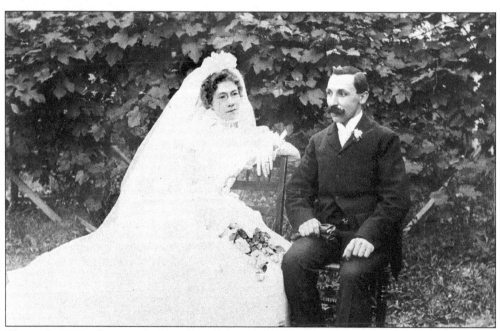

This early-1900s photograph shows Rita Peltier (of Congress Street in Cohoes) and Herbert De Fossé (of Worcester, Massachusetts) celebrating their wedding day.

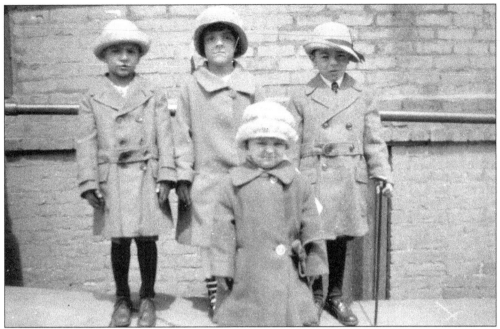

The Plouffe and Patnaude children are shown dressed up for Easter *c.* 1915. Making a face in the front is Jeanette Plouffe. From left to right in the back are Alfred Plouffe; Albina Plouffe; and Alfred Patnaude, with a rakish hat and walking stick.

Sisters Ida and Marie Lussier are dressed in the classic bob-haired fashion. Their total look epitomized the flapper style of the 1920s.

This photograph of Anna Lussier and her son Marshall shows him in his baptismal attire. He was clearly a well-behaved child; if he were squirming around, he would be a blurry image. Her dress hat is modest compared to the excesses of the Edwardian age.

This photograph, taken c. 1920, shows a group of Cohoes workers. The only person identified is Moise Plouffe, on the right in the bottom row, with the dog and cigar.

112

These smiling Cohoesiers are shown on a Cayuga Street porch c. 1916. From left to right are the following: (front row) Anna Mae La Feniere Reil and Julia Rose Reil Patnaude; (middle row) Ludger E. Plouffe, wearing a bow tie; (back row) Albina Reil Plouffe and Henry Reil. The child standing at the top of the stairs is unidentified.

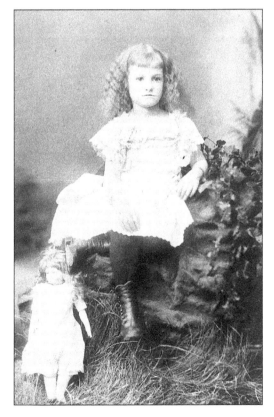

This enchanting photograph of Bertha Peltier and her prized doll was taken c. 1890 at the John H. New studio, located at 29¹/2 Remsen Street.

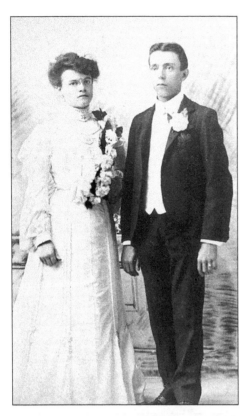

Mary Louise Robert and Joseph Lussier were married at St. Joseph's Church on August 4, 1904. A summer wedding still required the proper groom to wear black. Mary Louise is in white, even though this was not a tradition until a later time period.

This classic group photograph was taken in front of 6 Lansing Lane. It was common to use your house as a backdrop to indicate to others that you had acquired some position. Pictured are Jeanette and Leo Borden and Ed Nedeau.

Angeline (Boulerice) and Olivier Robert strike a serious pose for this c. 1900 photograph. Studio photographs like this were very common for most households.

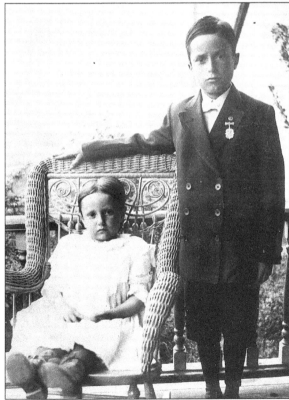

Ida and Marcel Lussier are shown enjoying the front porch at 68 Edward Street. The front porch was the center of community activity during the end of the Victorian era.

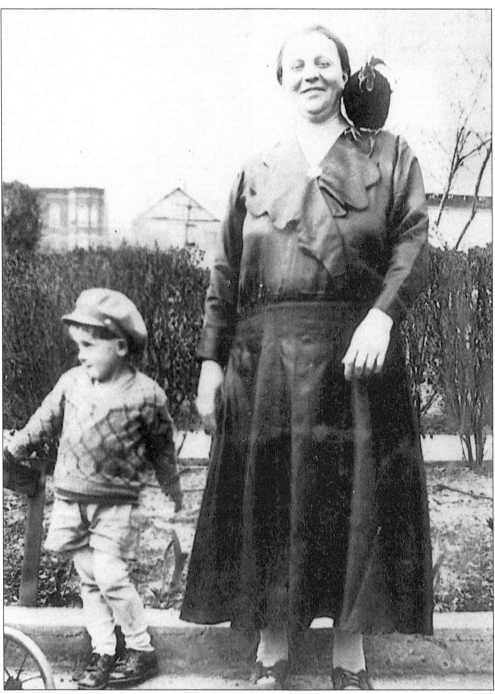

This 1932 photograph of Pelahia Cherniak and her three-year-old son, Vladimir, was taken near their home on Koscuisko Avenue. One of her prized bantam roosters also poses for the camera. Cohoes contained numerous ethnic enclaves populated by immigrants and their families. Most of these neighborhoods prominently featured a church. Koscuisko Avenue was home to several groups, among them Poles, Russians, and Ukrainians. The Cherniaks were members of the Russian Orthodox community.

# *Ten*

# STREET VIEWS

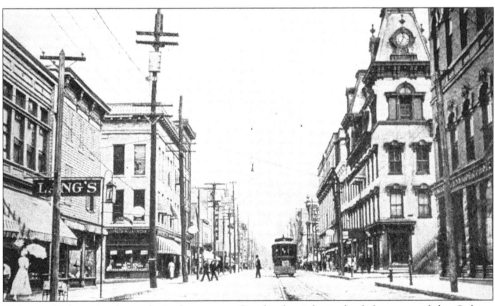

This was Cohoes in the early 20th century. On the far right is the left corner of the Cohoes Music Hall with its original facade. The building with the awning is now Calkins Pharmacy. The trolley ran down Remsen Street and provided Cohoes with an easy means of transportation to and from neighboring cities. Hanging over the center of Remsen Street is a carbon arc lamp typical to this period.

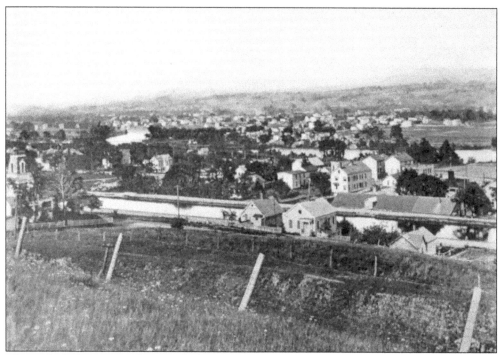

This early-20th-century photograph depicts Central Avenue with the Erie Canal in the middle ground. Grand View Park, the spot from which this picture was taken, is now covered with newer houses.

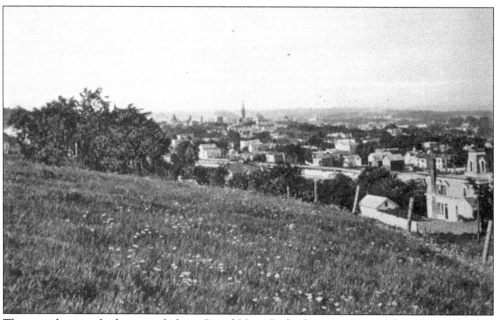

This was the view looking north from Grand View Park, showing some of the great sights that used to be visible from the various vantage points around the city of Cohoes. Grand View Park no longer exists, but scenic overlook spots are still to be found.

The Episcopal church on Seneca Street is shown here prior to 1866. The Ogden Mill is in the background.

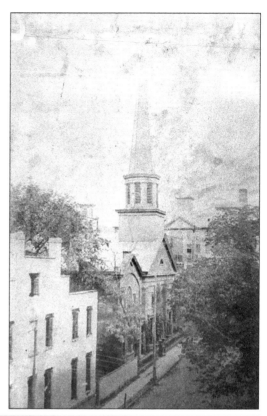

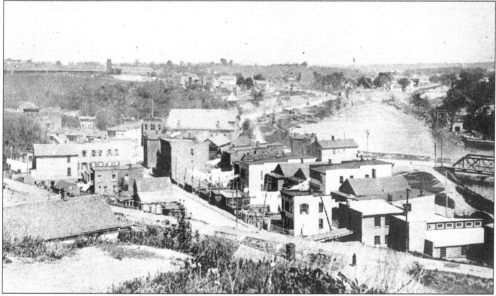

This photograph of "the Orchard" was taken from the top of Egbert Street c. 1920. The canal cuts through on a diagonal. In the foreground is a remnant of Lansing's fruit orchard, from which the area derives its name. In the distance is the Cary Brick Company. In the center are St. Patrick's church and school. To the right in the center is the firehouse for Hose Company No. 2, which closed c. 1916.

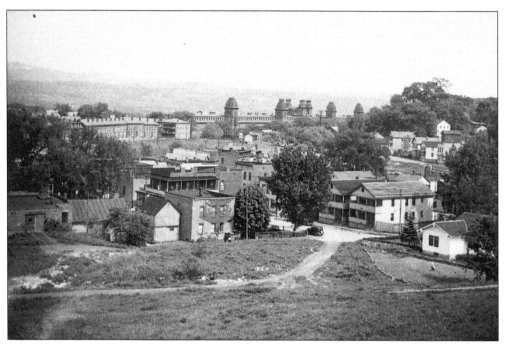

This photograph was taken from the hill near Lansing Lane. The panorama encompasses portions of the Orchard and highlights the distinctive skyline of Harmony Mill No. 3. Visible are some of the brick tenements that housed mill workers. The canal was in the foreground; remnants of the limestone locks are still in evidence today. The Orchard retains its character as a distinctive neighborhood in Cohoes.

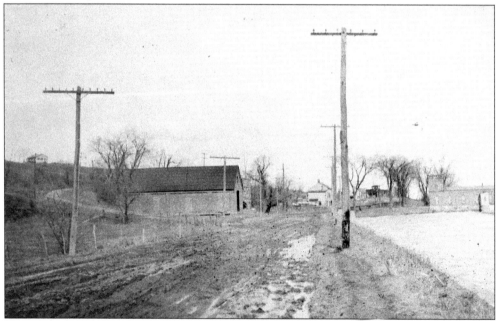

Here is the Cohoes-Crescent Road before it was widened and paved as a project of the Work Projects Administration (WPA). The power canal and the powerhouse can still be seen along the road today. This was one of the earliest roads for travel to Cohoes.

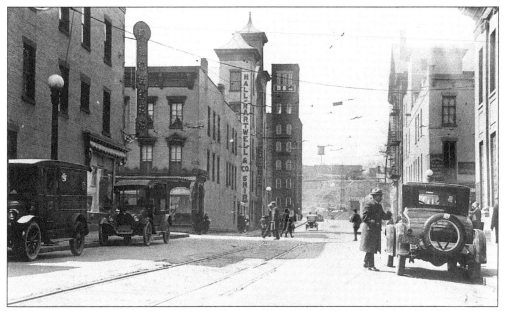

This early-1900s view is looking west on Ontario Street toward Remsen Street. The flower shop on the left marks the corner of Remsen Street, and a bank is on the right corner.

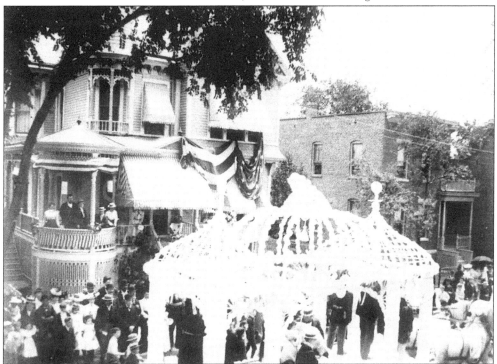

This photograph (taken on Congress Street in front of Dr. G. Upton Peltier's house) shows one of the floats used in the parade to celebrate St. John de Baptiste Day in 1908. The family can be seen on the porch. The celebration began with a High Mass and ended with a banquet in the parish hall. On the next day, there was a parade and picnic, followed by horse races and dancing.

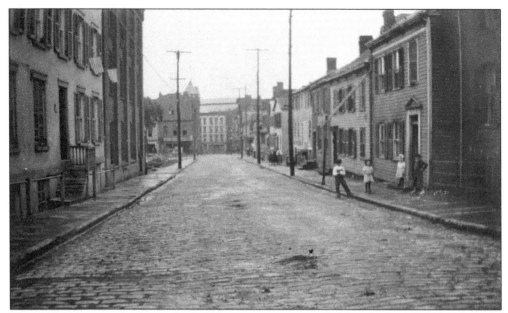

This 1916 photograph shows the cobblestone streets found throughout the city. Remnants are still visible in places where more recent paving has worn away. The streets and sidewalks provided a place for the neighborhood children to play.

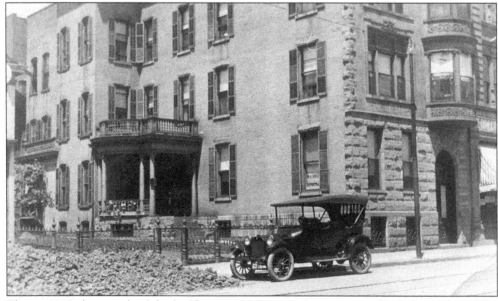

This *c.* 1915 photograph of the building at 134 Remsen Street is now the Cohoes Hotel. The Opera House building, located at 132 Remsen Street, also housed the Directoyu Tea Company.

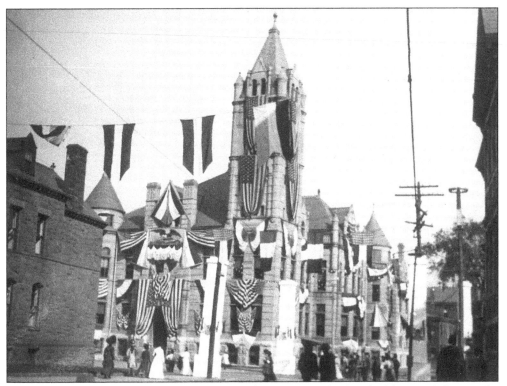

The Cohoes City Hall, completed in 1895 for $94,960, was the first building in Cohoes to be constructed with public funds. It is seen here decorated for the Feast of St. Jean de Baptiste *c.* 1902.

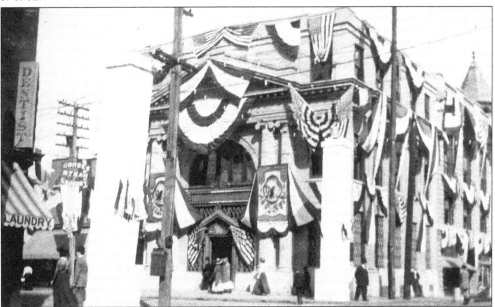

This *c.* 1902 photograph of the Manufacturers Bank of Cohoes and the Mechanics Savings Bank (both located at 91 Remsen Street) shows them decorated for the Feast of St. Jean de Baptiste.

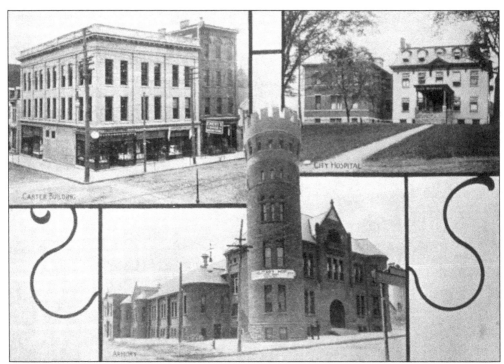

This grouping shows the Armory (at Hart and Main Streets), used by Company B of the New York National Guard. The Carter Building housed a department store at the corners of Remsen and Ontario Streets, and the third building is the Cohoes Hospital. The hospital buildings served the city until 1960, when a modern facility was opened. Price Chopper occupies the Main Street site today.

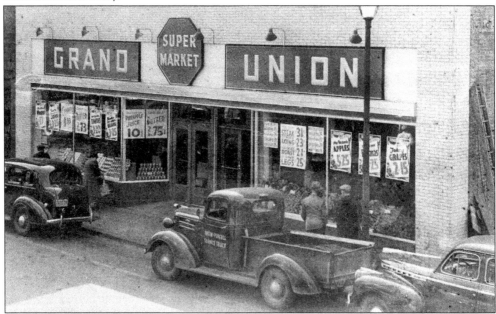

This is a 1930s view of the Grand Union Grocery Company store on Remsen Street. These Depression-era prices contrast dramatically with those in today's supermarkets.

This structure on Walnut Street is the Hampel family home. The house has been occupied by members of the Hampel family since 1859, a span of seven generations.

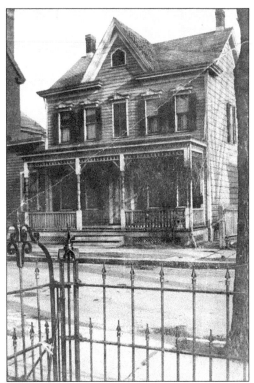

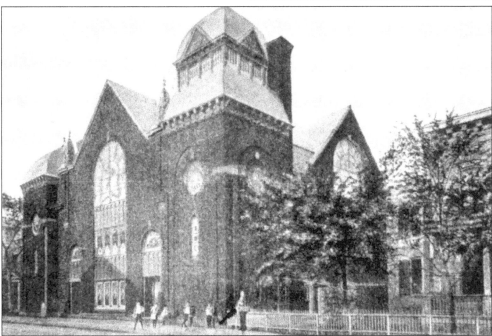

The First Baptist Church Society of Cohoes was formed on May 5, 1839. Its first pastor was Rev. John Duncan. The first church was built at the northwest corner of Remsen and Cayuga Streets and opened in 1840. In 1850, a Mohawk Street site was secured by perpetual lease and a new church was built. In 1898, the building acquired the general configuration seen here.

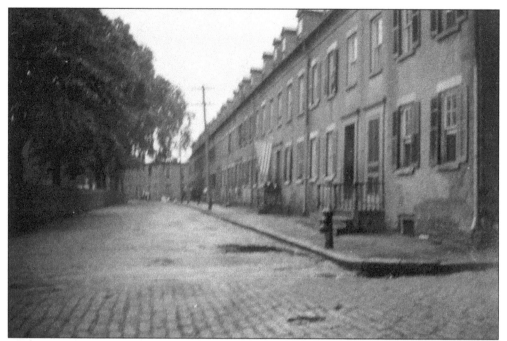

This row of Olmstead Street houses still stands today, the first group of many tenement buildings constructed for Cohoes mill workers. The photograph, looking south down the street, was taken in 1916. These tenements, as well as the ones near the Harmony Mills, are now all privately owned and constitute one of the largest groups of intact worker housing from the Industrial Revolution. These houses are part of the Olmstead Street Historic District.

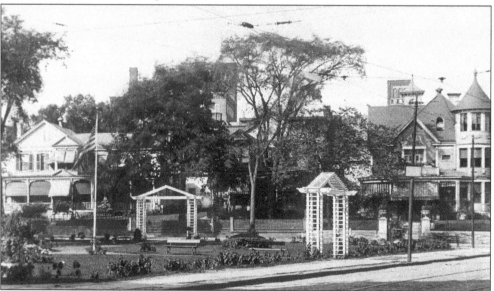

This lot—bounded by Ontario, Mohawk, and Canvass Streets—contained an honor roll for World War I veterans in the early 1920s. The city's post office, erected in 1924, is now located here. This photograph captures two fine examples of Victorian architecture on the southwest corner of Mohawk and Ontario Streets. These buildings were demolished to make way for an office building that is now occupied by a bank.

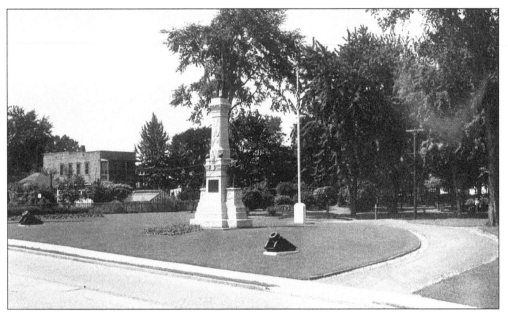

This is an early view of the city's West End Park on Columbia Street. The memorial in the park was dedicated in the early 1900s to the soldiers and sailors of the Civil War. The mortars alongside the monument were used in battle.

This snowy scene was photographed on Columbia Street c.1910. With no heavy snow-removal equipment, most snow was not rapidly removed after a winter storm.

This 1922 view is of the Hunt residence and River Road, north of the gatehouse. The deeply rutted unpaved road made for slow going when leaving the city of Cohoes, but many were sure to return to this special place at the confluence of the Hudson and Mohawk Rivers.

Lightning Source UK Ltd.
Milton Keynes UK
UKHW031630071222
413440UK00004BA/92